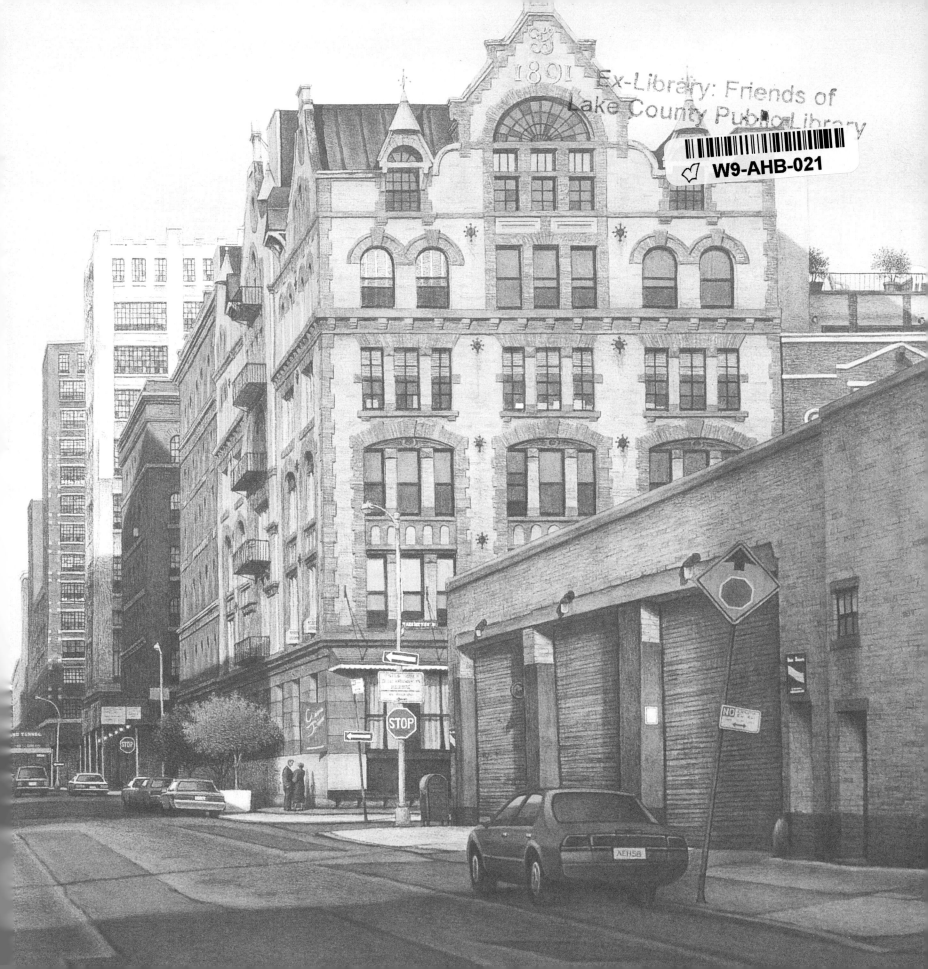

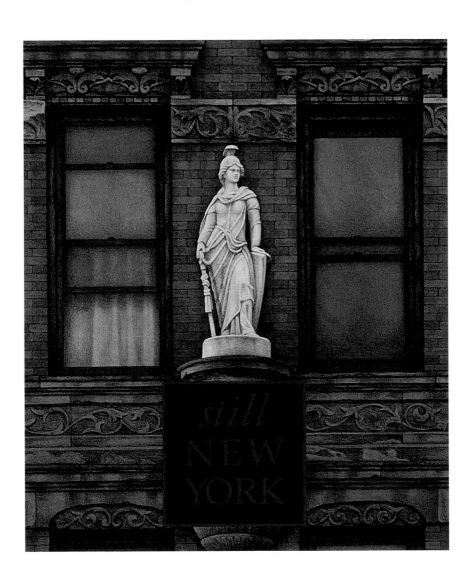

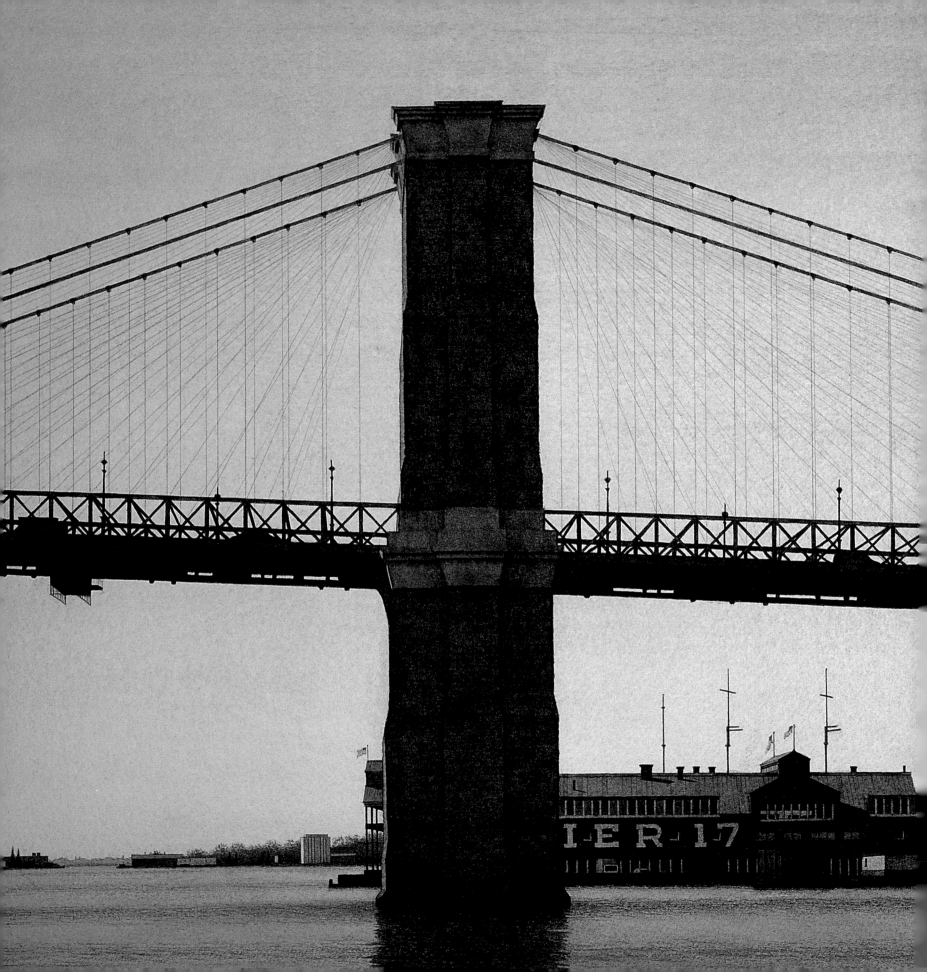

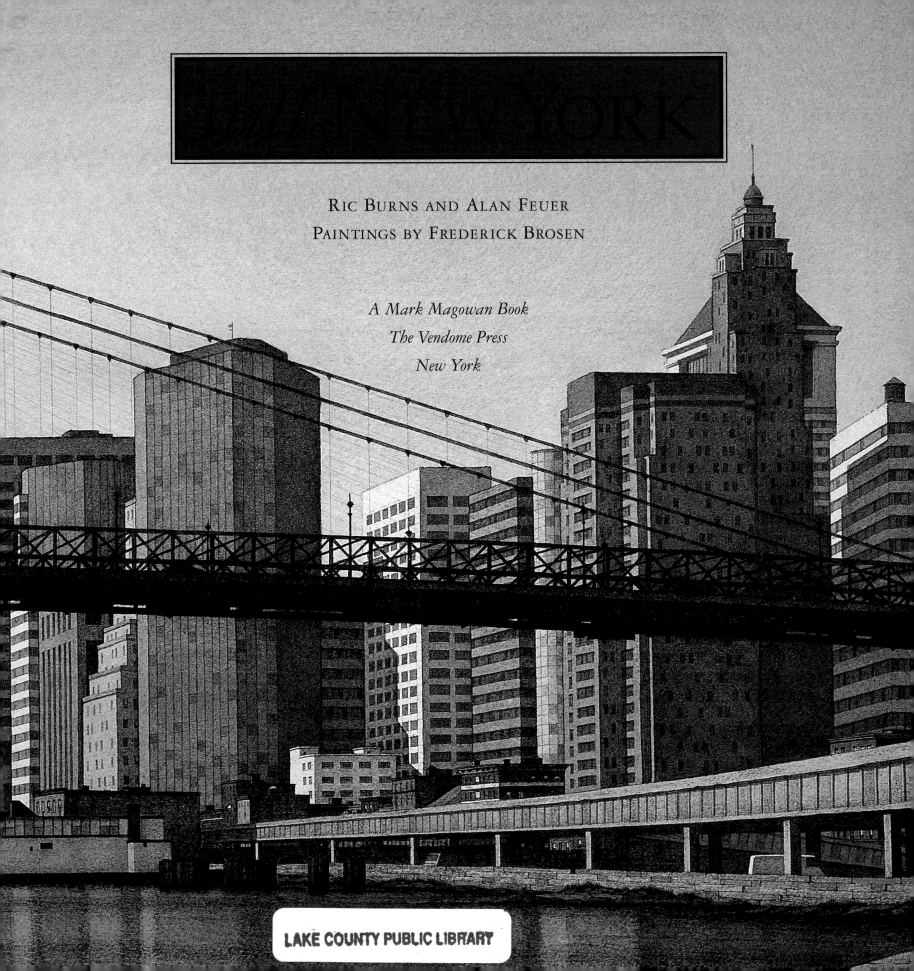

NEW YORK

Ric Burns and Alan Feuer

Paintings by Frederick Brosen

A Mark Magowan Book

The Vendome Press

New York

CONTENTS

ILLUSTRATIONS AND CAPTIONS COPYRIGHT © 2005 FREDERICK BROSEN
INTRODUCTION COPYRIGHT © 2005 RIC BURNS
ESSAYS COPYRIGHT © 2005 ALAN FEUER

BOOK DESIGN BY RENÉE KHATAMI
COPY EDITOR: SARAH KENNEDY

FIRST PUBLISHED BY THE VENDOME PRESS
A PROJECT FROM LTD EDITIONS

PRINTED AND BOUND IN CHINA

Jacket front: Broome Street
Jacket back: Woolworth Building
Case: Detail of the Henry Clay Frick House

Library of Congress Cataloging-in-Publication Data

Burns, Ric.
Still New York / by Ric Burns ; with commentaries by Alan Feuer ;
watercolor paintings by Frederick Brosen.—1st ed.
p. cm.
ISBN 0-86565-165-5 (hardcover : alk. paper)
1. Brosen, Frederick, 1954– Themes, motives. 2. New York (N.Y.)—In art.
3. New York (N.Y.)—Description and travel. I.Feuer, Alan, 1971–
II. Brosen, Frederick, 1954– III. Title.
ND1839.B76A4 2005
759.13—dc22 2005004397

To Sam and Isabelle,
New Yorkers born and bred.

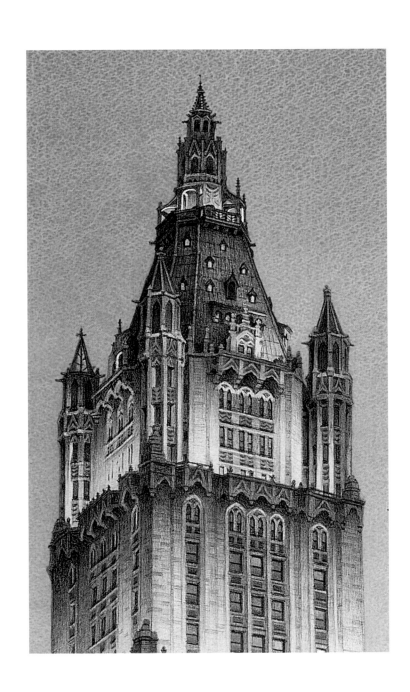

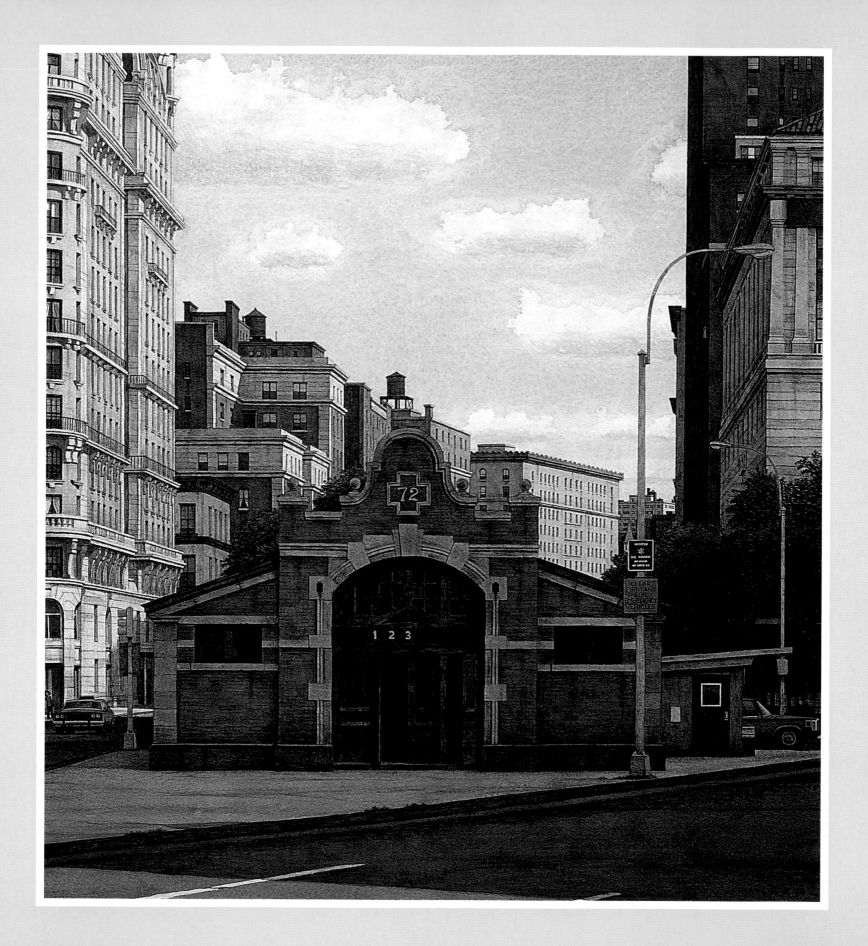

THE CITY AND TIME. HERE IS A VIEW OF THE CITY— of many, one. It is a morning view, looking north from about a block below the old 72nd Street subway station, showing the intersection of West 72nd Street and Broadway on the Upper West Side of Manhattan. At this hour, the quiet intersection—which unobtrusively occupies the lower third of the painting, and which includes, in addition to the quaint brick huddle of the station itself, a curve of merging avenues and the leafed-out trees of Verdi Square beyond—is still deeply plunged in anti-meridian shadow; while above, beneath an azure, cloud-softened sky, a mysteriously willful bend of sunlit buildings—the magnificent, century-old Ansonia in the lead—shows where Upper Broadway swings northeast as it makes its way uptown, back in line with the grid for awhile.

There are many things about this image that make one catch one's breath—most obviously and immediately, perhaps, the infinitely masterful

Detail of subway kiosk 72nd Street.

articulation of detail, the unselfconsciously classical composition, the quietly heroic use of light. What is most haunting about the painting, however—what in the end all the craftsmanship and artistry work in concert to reveal—is that in it you feel—as in so many of Frederick Brosen's extraordinary urban landscapes—how deeply embedded in time the city is.

I have a special interest in these paintings—no doubt in part because I am a historical documentary filmmaker who has lived in the city for nearly thirty years, and who for much of that time has nurtured a deep and long-abiding interest in the history of New York. I also have a special interest in this particular painting of West 72nd Street and Broadway. It is not merely a scene I know well, living and working as I do on the Upper West Side; it is a scene embedded so deeply by habit and experience in the muscle memory and nerve endings of my psyche that its familiarity to me has a kind of uncanny quality, like the dreams of our childhood, or the sound of the steam pipes in the radiator at night, or the image of a loved one's face. As a city dweller, I bring my own time to these paintings, in other words, and perhaps especially to this one—for many reasons, including the fact that I have worked for the last fifteen years in one of the structures it depicts: the small, five-story red brick building over on the left, just across the street from the Ansonia. The window of the office where I sit writing this piece is on the fifth floor of that building—the one farthest to the left. If I were to go to the window right now—it's right above the one on the fourth floor, with the white shade half-drawn—you would be able to see me waving.

None of which, I think, qualifies in any way the objectivity of my response to these paintings—or even the objectivity of my response to this one. On the

Detail from 72nd Street and Broadway.

contrary: whatever personal history or prior claim or random familiarity I may bring to these images only serves to heighten, to throw into higher relief, a crucial aspect of Mr. Brosen's work. There is a haunting familiarity about all his super-real cityscapes—large and small, uptown and downtown, whether you've seen the views they depict a million times or never before—a detached, observant, almost domestic intimacy, which oddly works to make them less predictable, more deeply resonant, and fresher to our sense. We've seen these scenes before—not because they are the iconic, symbolic views of New York, but because they, or ones like them, have been indelibly engraved on our vision somewhere along the way, sometimes with, sometimes without our noticing it. They are

Detail of the Evelyn Apartments on West 78th Street.

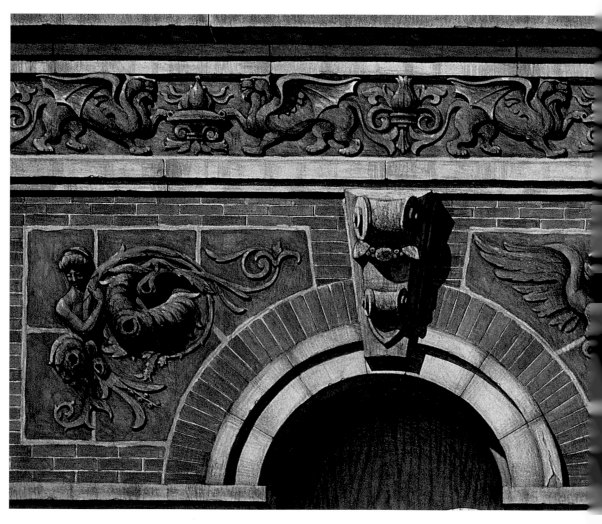

the places we have seen over and over again without really seeing; or glanced at staringly once and then quickly forgotten; or seen so many times we have stopped really seeing them at all. Here is the statue we have passed a thousand times. Here is a heart stopping stoop. Here are the often all but unnoticed upper stories of buildings, etched unconsciously upon the periphery of our vision, sometimes seen, often not remarked upon at all—the demotic entablature of our daily architectural awareness, in a city of dazzlingly mixed and multiply layered functions and uses—a collective, only partly conscious but still wide-awake dream world made of architraves, cornices, seraphim, lintels, and friezes—almost always either just above or just below

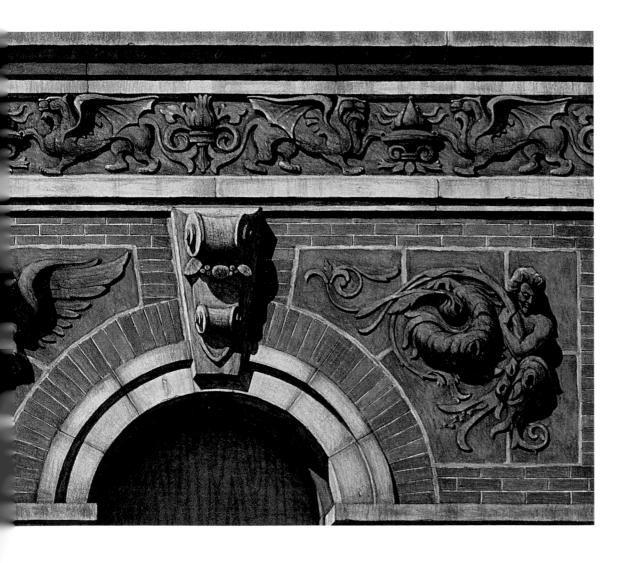

or too far to the left or right of the blindly goal-directed sight-lines of our daily lives.

In the end, perhaps, Mr. Brosen might be thought of as painting neither the collective consciousness of the city, nor its collective unconscious, but rather its collective periphery—the scenes we take in every day, but rarely focus on—the scenes that seep osmotically into our senses when we are paying least attention—so that when we see them again in his paintings it is with a startling sense of both deep familiarity and striking candor.

And there's something else here, too. It's uncannily as if in these paintings not only are we looking at the city, but as if the city is looking back at us, too.

In the deepest and most fundamental sense, time and the city are Mr. Brosen's obsession, love affair, and main subject. So many temporalities are implicated in his work that it might be useful to start by pointing out the kinds of time his paintings don't involve. Individual human time, for example, is not really his subject (other than the implied human time of the viewer and the artist himself—which in these paintings involves a kind of deeply meditative, self-dissolving awareness of the real—a profound communion with and intuition of the other, of the kind the poet, John Keats, called "negative capability"); nor are people per se, who never loom large in his paintings and are often absent altogether. It is not the time of individual experience that draws him to the city, nor the temporality of people in the daily rounds of their lives—which is not to say there are no people in his paintings. In West 72nd Street, for example, there are six to be exact, if you look carefully enough with a jeweler's loupe: three shadowy taxi drivers, a pedestrian in a white shirt and straw hat, a woman walking

with her child on Broadway, and another waiting to cross Amsterdam at 73rd Street. But the city's people aren't really his subject, nor is the city's hectic surface rush, the momentary, kinetic ebb and flow of the daily metropolitan hustle-bustle.

If the time we experience in Mr. Brosen's paintings has nothing to do with the superficial outward rush of urban life, it also has nothing to do with the philosophically exacerbated, subjectively supercharged temporality of, for example, Edward Hopper's cityscapes—where a kind of haunted inward light—psychological, existential, theatrical and erotic—suffuses the viewer, as it suffuses the people and objects in his scenes, with all the inward and subjective modes of time: the time of waiting, the time of unfulfillment, the time of mortality, the time of desire. In Hopper's world, time and light steal across the canvas, undermining from within the solidity of people and things, vampirically draining the objective reality of his scenes (not that there's anything wrong with that). By contrast, in the serenely epic temporality of Mr. Brosen's paintings, time and light softly inhabit the world—embracing and lambently touching it—as if to awaken the world more fully to itself and, by enhancing our awareness of objects and things, affirm the actuality of the real.

So what is the time—what are the temporalities—that these paintings evoke—so patiently, so powerfully, so exquisitely? Go back to West 72nd Street for a moment and look again: city time is everywhere. There is, to begin with—negligibly—the temporality of the very light morning traffic flow through the grid system of Manhattan, stopped momentarily as the north-south flow pauses for the light at 72nd Street and Amsterdam. More to the point, there is the time of day—the turning of the planet—something we can't tell from the darkened

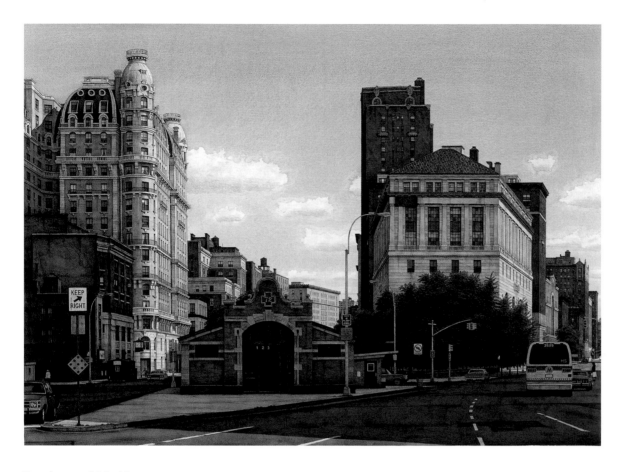

Broadway and 72nd Street.

electric clock on the Apple Bank (which mysteriously isn't on) but that can still be descried from the tiny clock on the corner of my office building. (See it? Just to the left of the subway kiosk? Get out your jeweler's loupe. It's around eight o'clock.) Denizens of the city, who carry within themselves, whether they know it or not, an intuitive knowledge of where and how the light falls at any given time of day and year on the buildings of the grid, don't need to ask what time it is. They know without having to be told that this is a summer morning—a quiet Saturday, or a weekday perhaps, just before the dam breaks and the work-day begins—for only then does the light fall just so across the face of that white

building. Not to mention, of course, the luxuriantly leafed out copse of trees, which speaks of the promise of June.

Beyond the time of day and year, there is another temporality inscribed in the painting: the temporality of the *longue durée* of city life—the ceaseless urge to fabricate and build that drives the city's ongoing metamorphosis—the unending cycle of creation, destruction, and renewal that underlies and continually transforms the city's surface—the semi-geologic rhythm of each neighborhood's rise and fall and rise again. This is legible here, as it almost invariably is in Mr. Brosen's paintings, in the sharply highlit juxtaposition of architectural styles and periods—in the uninflected reminders of structures past and structures to come (on the left, behind that blue fence on the corner, one building has just come down and another will soon go up)—and even in the overall compositional tensions: the proud bright verticality of the buildings braced against the dark and lapping horizontal flood of the boulevards.

Then again—arising as separate movements or beats within this ongoing urban rhythm—there is the temporality of each extant piece of converging architecture: the Beaux Arts glories, big and small, of the Ansonia and the subway station, both completed in 1904; the sturdy Neo-Classicism of the Central Savings Bank (now the Apple Bank), finished in 1928; and the high-rise Art Deco elegance of the Beacon Theater beyond, completed that same year—each structure captured and held, appropriately enough, at a time and place of thrilling convergence and intersection. What all these temporalities taken together gloriously evoke is the semi-geologic temporality of city-time itself—perhaps we could call it "metrolithic" time—the persistence (always only

partial) of the past in the present, and the long cycles of growth, destruction, and renewal that have brought the city to its current bank and shoal of time. This is Mr. Brosen's real subject—the city in time; the city in the process of lasting—and by disclosing the shimmering temporal depths within which it has arisen and the many temporal layers it comprises, his paintings provoke an almost voluptuous awareness and love of the urban landscape—affirming, along the way, the city's deep temporal mystery, and almost numinous physical beauty.

PALIMPSEST. Any great city is also a kind of palimpsest—a wonderful word, which comes down to us from the Greek by way of Latin, and which literally means something that has been "repeatedly scraped or rubbed away." It was originally used to describe a manuscript, typically made of parchment or papyrus, on which more than one text had been written, and on which the incompletely erased traces of earlier texts were still visible. By analogy it has come to describe any object or place whose top layers have been (at least partially) rubbed away—thus exposing the older layers or aspects beneath the surface. As such it perfectly describes the kind of place Mr. Brosen is instinctively, one might almost say helplessly drawn to.

To a certain extent—for those hungry for the timescapes palimpsests disclose—any old city will do, and Mr. Brosen has, in fact, also painted strikingly handsome cityscapes of Paris and London. But one senses that for him New York is somewhat different—and not only because he is a native New Yorker who has lived his whole life here, though that is something readily enough apparent, I think, from his paintings of the city. (As in a film by Woody Allen

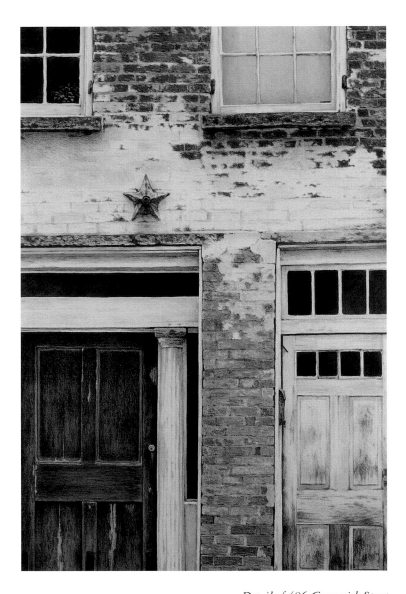

Detail of 486 Greenwich Street.

Detail of Gansevoort Street I.

or Martin Scorsese, there is no outside to one of Mr. Brosen's paintings of New York—no sense that there could be any place larger or more compelling than this infinitely dense and absorbing universe.) Perhaps it is that the layers of history have been laid down more quickly, and to some extent less durably here—allowing not only for more layers and displacements, but for more rapid corrosions and erasures—more "rubbings away"—and thus for more rapid revelations of the past. For whatever reason, New York's palimpsesticity seems rawer than that of other places—as if each layer of time here were closer and more vulnerably open and exposed to those that have come before and after—as if each successive wave of the city's history were a new episode in some ongoing unresolvable multi-generational sibling squabble. One way or another, the rapidly iterated cycles of creation, destruction, and renewal that have characterized the city's growth have, over the last four hundred years, yielded the densely textured, multiply layered, entirely fabricated palimpsest that is the city—and with it the exquisite, organic, half-accidental harmonies of chaos and order that are the recurrent subject of Mr. Brosen's best paintings.

Not every place in the city, of course, is equally palimpsestic, and for that reason Mr. Brosen is naturally drawn primarily to Manhattan—and indeed more to certain places in Manhattan than to others. As a general rule for him, the farther downtown you go the happier the hunting, and what draws his eye are the places where multiple strata of time and style and history coexist; where the reality of mixing and the aura of lasting intersect. He loves the places where red brick bleeds through whitewash—where the painted signage of a long defunct commercial concern fades silently towards oblivion—where traffic and time have rubbed through the streets to reveal the centuries-old

Belgian paving stones. He loves to find heraldic devices here on the shores of the new world—sculptural ornaments and classical scrolls, ecstatic seraphim and gargoyles. He loves places where maximum fabrication and artifice have taken place, from Central Park to SoHo, and places where many things, either all at once or slowly over time, have been crowded together willy-nilly: where factories, garages, churches, and homes sit side by side along a side street; where mosques and temples and churches and banks coexist with skyscrapers, carriage houses, and tenements. He loves places where the march of time has forged hybrid identities. At the intersection of Canal Street and Division in Chinatown, a stone's throw from the government district, three centuries of architecture—commercial, residential, high-rise, low-rise, religious, vernacular, and classical—can be seen converging on a single intersection: hurtled together by the sheer force of the city's strangely centripetal instinct for heterogeneity. As a rule, he's most at home in lower Manhattan—in Chinatown, Little Italy, the Lower East Side, and the Village—and Broome Street and the Bowery might be his ground zero. But the right vantages and details can, like epiphanies, burst forth and reveal themselves almost anywhere: in an oily row of auto repair shops along West 53rd Street; in the plywood-covered windows of a red brick town house on 78th Street and Columbus; in the Angel of the Waters at Bethesda Fountain.

In all of these places, it will come as no surprise, Mr. Brosen is looking for scenes that allow him to indulge perhaps his signature addiction as a painter—his obsession with almost infinitely exquisite gradations of detail. The deceptively obvious pleasures of the super-real, to say nothing of the extraordinary challenges, are not always sufficiently appreciated in our super-sophisticated

postmodern day and age; and, in so doing, we sometimes overlook, or even willfully ignore, how often art plays upon one of our most primal fantasies—the primordial, no doubt deeply childish thrill of the miniature. From start to finish, of course, Mr. Brosen's work is intimately bound up with the fantasy of the microcosm, and a significant portion of the extraordinary delight we take in his paintings will always come from their infinitely painstaking fidelity to reality: from the degree to which the little world of his art appears to mirror the macrocosm of the real world—from the degree to which, by the magically severe and hard won illusions of painting, we are made to feel that a whole universe has been faithfully captured, shrunken, and reassembled whole in the little world of the painting—such that we could, if we wished, go infinitely far down into that alternative universe, and never exhaust the increments of detail we find there.

Two stages of the Doyers Street painting.

The virtuosity with which Mr. Brosen renders these tableaux is hard to overstate, but it is not a virtuosity for its own sake. It is, rather, wonderfully calibrated to the subject at hand and it would be hard to imagine a more perfect marriage of subject matter, manner, and method. In the evolution of a painting like his extraordinary study of Doyers Street (see page 50)—a tiny elbow of a lane in Chinatown connecting Pell Street and the Bowery—we can witness, step by step, the emergence of a kind of parallel artistic palimpsest in reverse, as layer by layer—from the first black-and-white underdrawing to the last wash of color in the sky—Mr. Brosen recapitulates, in the orderly universe of his painting, the more haphazard physical and historical evolution of his subject.

In the end, the best of Mr. Brosen's finished paintings locate a glorious aura of permanence amidst the continual flux and ferment of the urban scene. Most of us know what it is to wish for things to last, but perhaps some of us wish for it more intensely than others, and Mr. Brosen may be one of them. He was six when his father was stricken with multiple sclerosis, nine when his mother killed herself in the waning days of November 1963—it was the

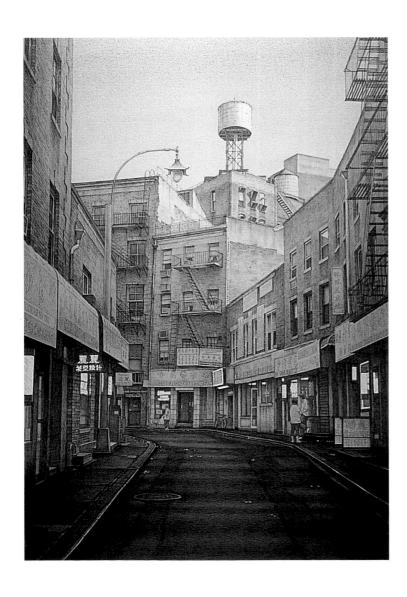 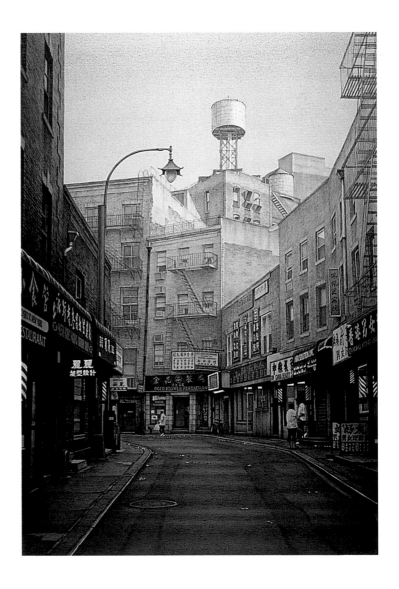

weekend following the assassination of President Kennedy—and the subsequent childhood he shared with his older sister was apparently one of grinding financial hardship, anxiety, and stress. By his own account, he became a kind of street urchin, by which he seems to mean that as he grew up he spent a great deal of time out-of-doors on his own, wandering the streets of New York. It probably isn't any wonder that, given such a background, he came to feel more reliably connected to places than to people, who would come to haunt, if they haunted them at all, only the periphery of his paintings. Nor that he should have developed a special knack, amidst all the hurly-burly of the city, for finding beauty and staying power in the streets. It's still there, one hears a small voice crying out. There's still New York. Still New York.

<div align="right">RIC BURNS</div>

Doyers Street.

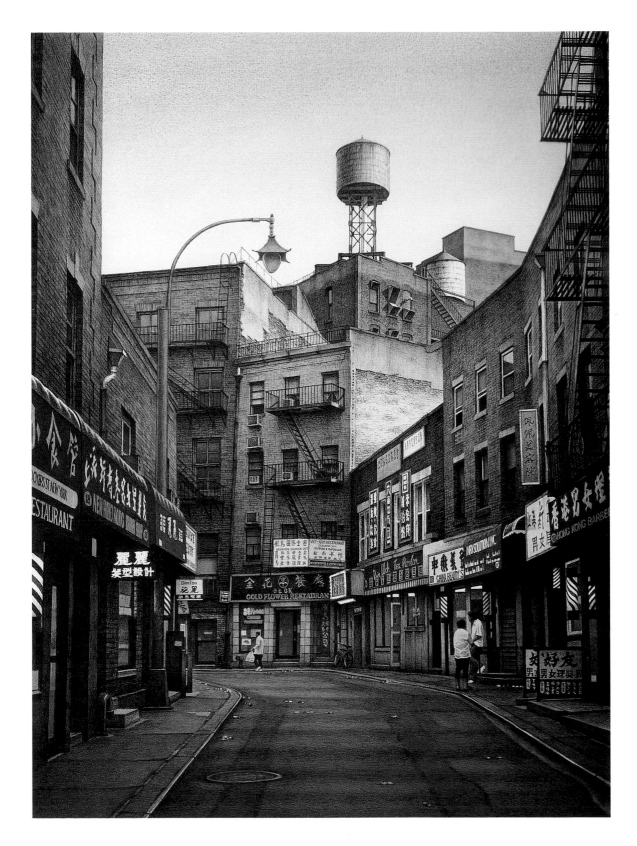

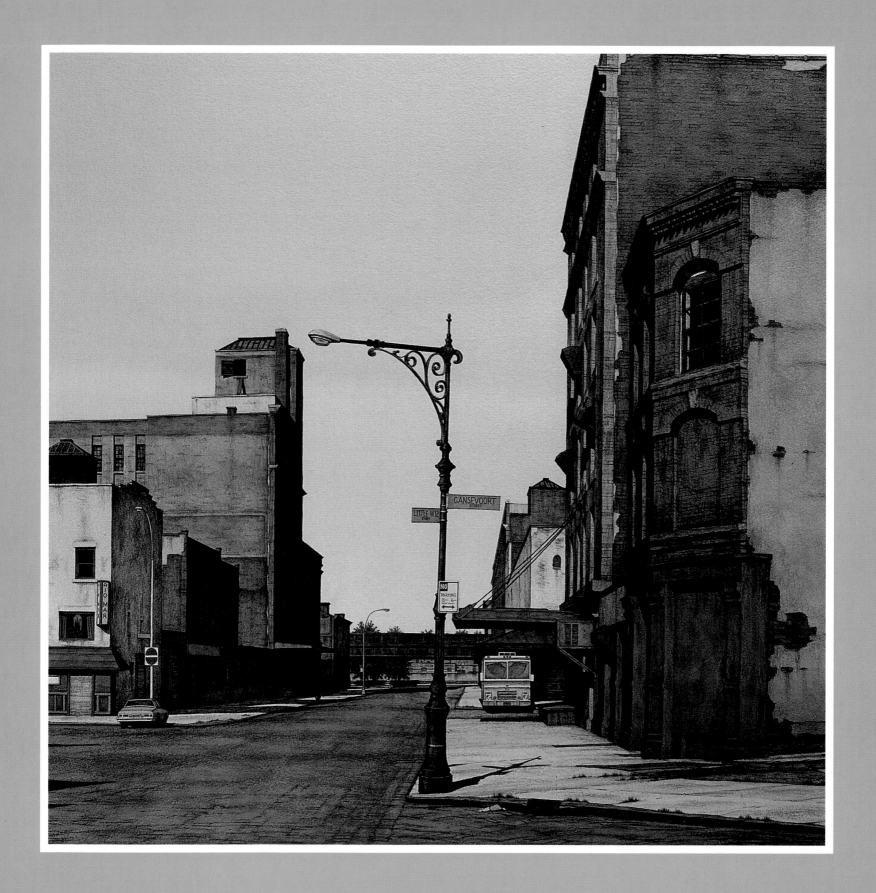

EXCEPT FOR A FEW YEARS IN THE LATE 1960S, WHEN he moved uptown to manage the Cattleman and Chandler's, looking for the cleaner sort of work that restaurants provide, Howard Landress has for more than five decades worked meat at the Gansevoort Market, better known as the Meat-packing District, on Manhattan's lower West Side. One day in 1952, he carried his book bag from a class at the Food Trades Vocational High School on West Thirteenth Street to a pork house on Washington Street called Shattuck and Company. It was there he landed his first job in the meat business. Landress was sixteen years old, and the job required him to dust the floors with sawdust and scour the bloody butcher blocks with a heavy brush and salt. It was hard, demanding work and his official title, so he says, was "Bottom of the Fucking Rug."

Landress moved on to the post of "scaler" for a second company called *Detail of Gansevoort Street I.* Holiday Meats. He stood on a loading bay, beneath a sloped metal awning,

weighing cuts of pork, lamb, and beef on large industrial scales. After that, he worked as a butcher for Pearlmutter Brothers, which owned the meat concession at Macy's. At the time, he said, there were a hundred butchers who displayed "the fanciest meat in the world" in glass-fronted cases on the store's first floor, where cosmetics and perfumes are now sold. In 1955, he was drafted by the army to run a meat plant for the Atomic Energy Commission at the Eniwetok Proving Grounds on Eniwetok Atoll in the South Pacific. "I never saw a broad or a tree for thirteen months," he said. After his military service, he took a break from meat and worked four years in the restaurant business. But by 1968, he had returned to the market as a meat broker, working for his uncle, then for himself, at a company called New York Wholesale Meat, which supplies meat to hotels, restaurants, and country clubs throughout New York. These days, Landress, who is sixty-eight years old and still has the husky frame of a man who spent his young adulthood hauling beef, is supposedly retired, though you can find him at his regular table down at Hector's, writing orders for veal top rounds, sweet breads, or whole pigs at half past five in the morning, an hour or so before the sun comes up.

Hector's is one of the few old-time places left at the market. Hector is gone, but his coffee shop remains, and from two until seven o'clock each morning, it is populated by the scrubbers, scalers, butchers, brokers, lift operators, and long-haul truckers who have earned their living in the meat business, ever since the industry first came to the neighborhood in 1887. In the early nineteenth century the market, bounded by Gansevoort, Washington, West, and Little West Twelfth Streets and by Tenth Avenue, was underwater, but by 1851 the land had been filled in. A city market, mostly selling produce from Long Island and New Jersey, was erected at the site on June 14, 1884. Three years

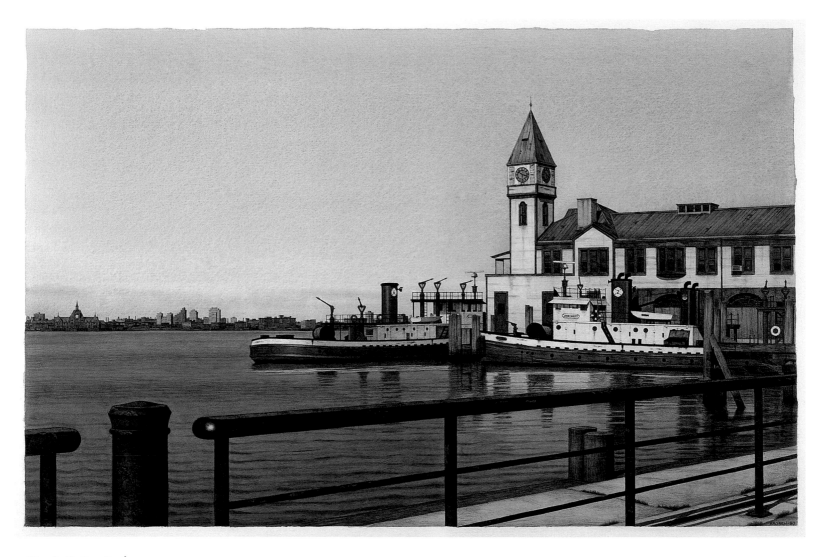

Pier A, Battery Park.
The pier, at the north end of Battery Park, is now headquarters for the
Marine Division of the New York Fire Department. It is the last remnant
of a much larger maritime complex built in 1900, which included a firehouse,
breakwater, boat landing, and an auxiliary pier added in 1908. The
picturesque clock was added in 1919 as a memorial to servicemen
killed in World War I.

Watts Street.

To the east along Watts Street stands the glazed, orange brick Fleming Smith Warehouse, built in 1891 by architect Stephen Decatur Hatch. Distinctive for its neo-Flemish gables, it originally housed a shoe factory and wine storehouse. Today an excellent French restaurant occupies the ground floor. Watts Street is one among numerous Tribeca streets rich with 19th-century manufacturing and storage buildings, many now converted into luxury lofts. The landmark status of several blocks in this area ensures its architectural legacy, even as recent financial district developments rise to the south.

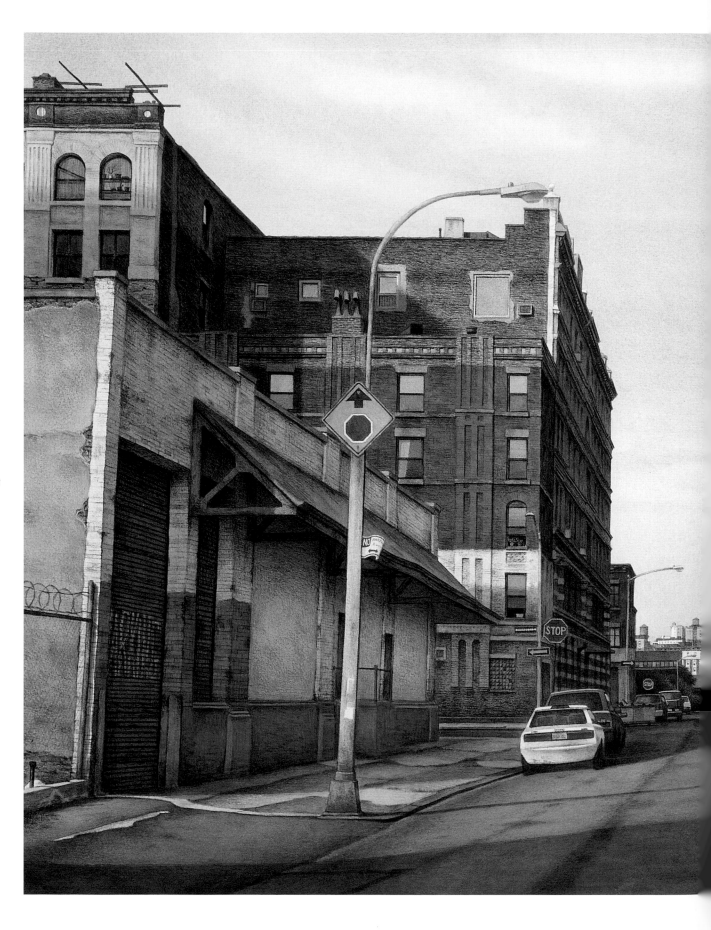

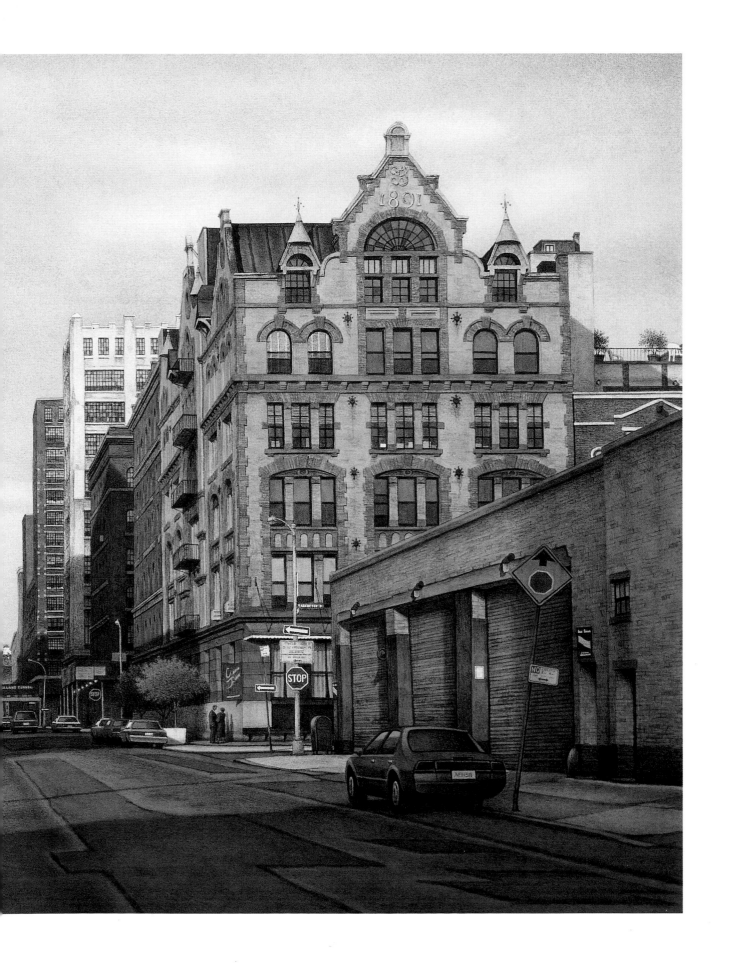

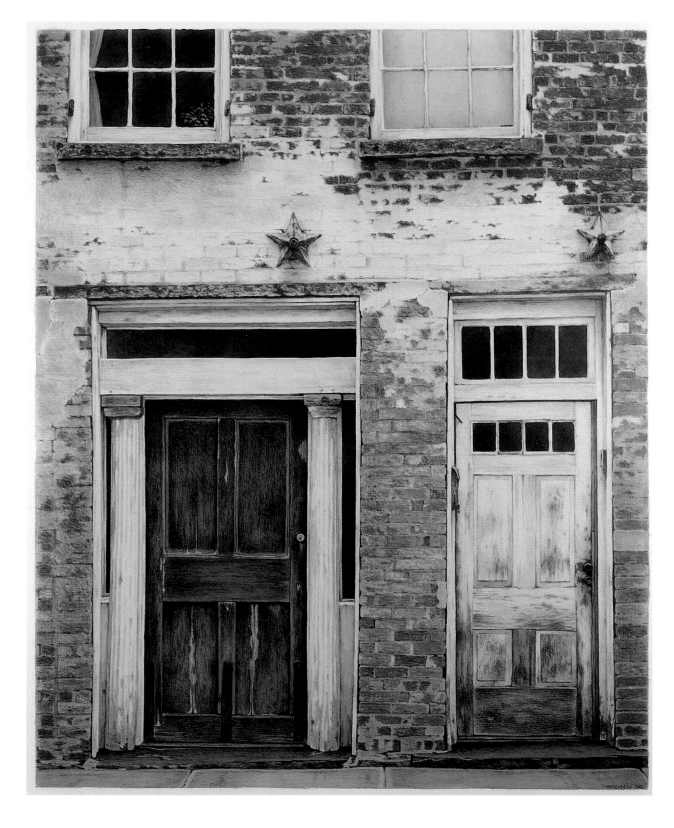

486 Greenwich Street.
This tiny Federal-style house stands along Greenwich Street near Canal Street, a reminder of a vanished period when the area was populated by low brick buildings with dormered roofs. Odd angles of the doors to the upstairs windows and the varying color of bricks signify a history of rebuilding. The two iron stars are actually the caps of iron rods running through the wooden floors, which supported buildings of this time.

later, the city built the West Washington Market for the egg, poultry, and meat trades, which survives today bearing the name of Peter Gansevoort, a Revolutionary War hero. (Gansevoort's grandson, Herman Melville, worked for nearly twenty years as an inspector for the city's Department of Docks, head-quartered at a river terminus at the end of the block.)

In the old days, Hector used to hang a bed sheet over the lunch counter, set out candles in the evening, and then serve steaks from his short-order kitchen. According to Landress, "the old days" ended five or ten years ago, when the district changed for good. "Down here was a very rough trade," he said. "Used to come to work in the morning, there'd be three, four bodies lying dead in the street. They tore up a building not long ago, pulled out the elevator, and

found a body had been lying there for twenty years." Because the neighborhood is isolated, it became the stomping ground for homosexuals and transvestite prostitutes in the 1970s. There were bars like the Anvil, where men could go to do rough things to one another, and Mineshaft, where the management went so far as to set out an old wooden stock for those wanted to partake in a particular form of sex. The meat men drank at Howley's, which is now Hogs and Heifers,

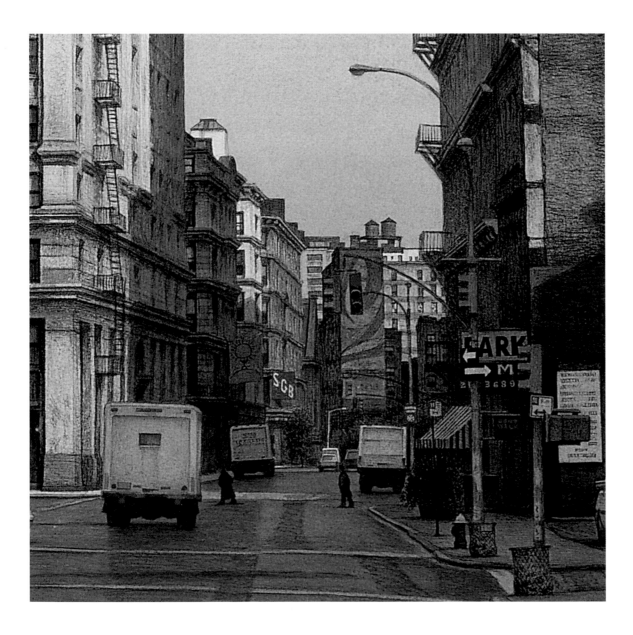

Broome Street.
South of Houston Street (SoHo) offers a concentration of cast iron facades popular in mercantile construction in the 1880s and 90s. Also built in that era is a striking exception—the steel framed, twelve-story building at the corner of Broome and Broadway designed by John T. Williams in 1896. The building has only three bays on the Broadway front, but 26 bays as it runs a full block along Broome Street. The top three stories are a baroque delight of pilasters and spandrel arches, crowned with a broad oxidized cornice.

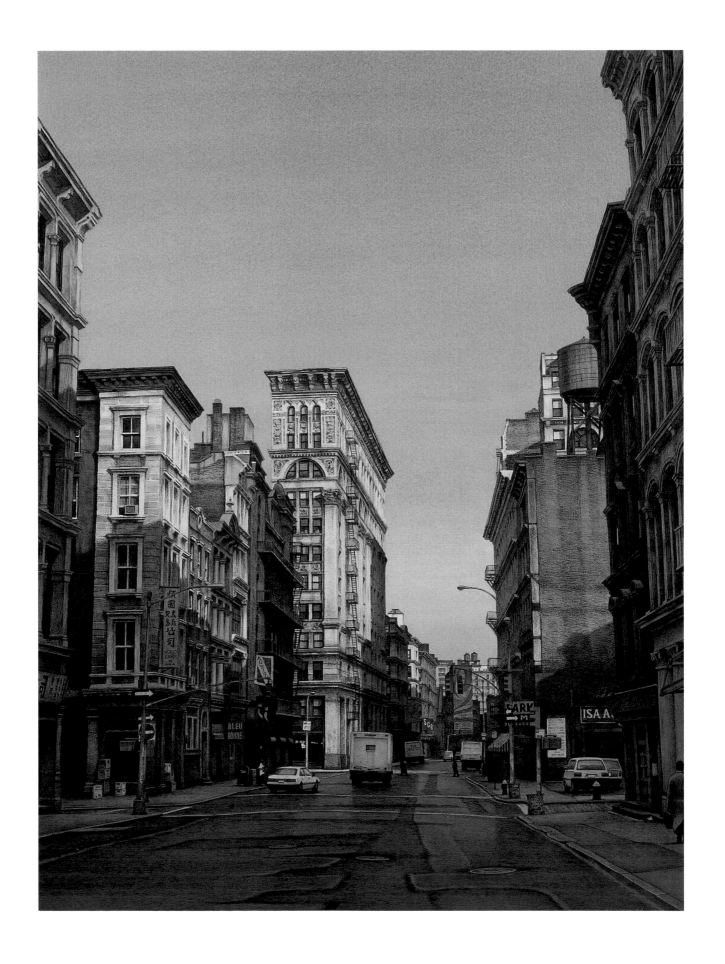

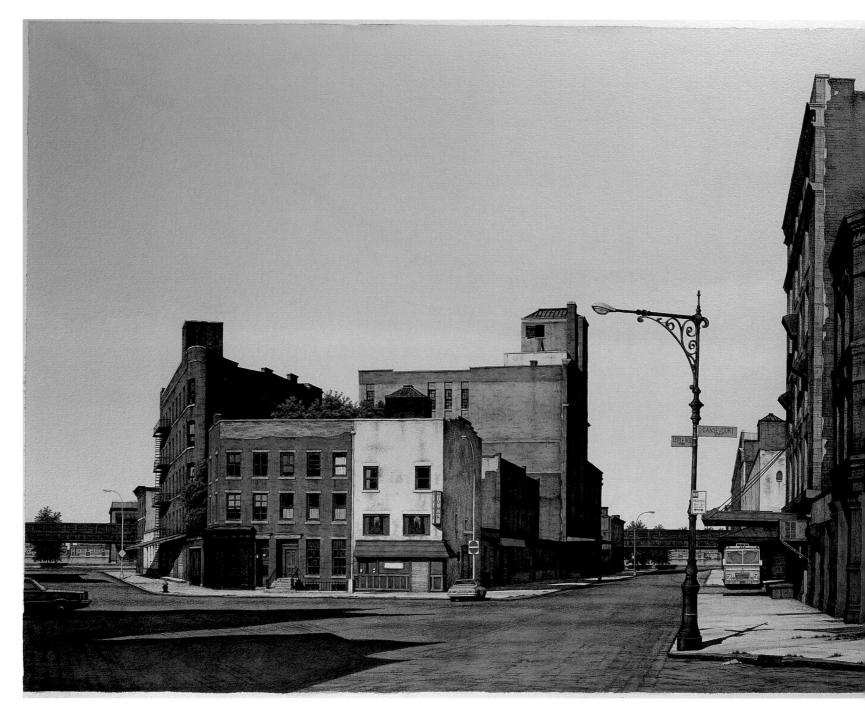

Gansevoort Street I.
Gansevoort Street stretches west from Hudson Street to West Street
in the northwest corner of Greenwich Village. Along its wide
expanse both Greenwich and Washington Streets commence and
run south through some of the Village's most picturesque streets.

In the 19th century the area was a large farmers market and
subsequently home to several meatpacking plants. Today it is an
uber-hip destination, replete with fabulous people, restaurants,
and hotels.

and mostly ignored "the shenanigans," as they were called, although it sometimes happened, Landress said, "That you'd pull your truck to the curb and some guy would jump in your rig buck naked."

In 1900, the market was comprised of two hundred and fifty slaughterhouses and packing plants. Today, there are less than thirty. There were more than three dozen on West Fourteenth Street between Ninth Avenue and West Street alone; now, there are two. The bloody knives and butcher blocks have been replaced by clothing shops and fancy bars, where a single dress or night of drinking might cost you more than a quarter side of beef. As the meat men come to work these days, men whose fingers are routinely sliced, who are knocked about by carcasses, whose heads are struck by flying iron hooks, they share the cobblestones with a different breed of man—one who may not know what part of the cow filet mignon comes from, but knows exactly how it tastes.

"It's been mind-boggling," Landress said. "I bring my wife down here on a Saturday night, there's five-hundred dollar shoes and nine-hundred dollar pocketbooks."

"I have to laugh because it's so totally out of my league," he said, "and I make a good living, knock on wood."

Gansevoort Street II.
The low 19th-century buildings and broad intersection of several streets
give Gansevoort Street an unusual urban feeling of expansiveness.
Cobblestones in the foreground, now mostly paved over, were once
ubiquitous in New York City below 23rd Street.

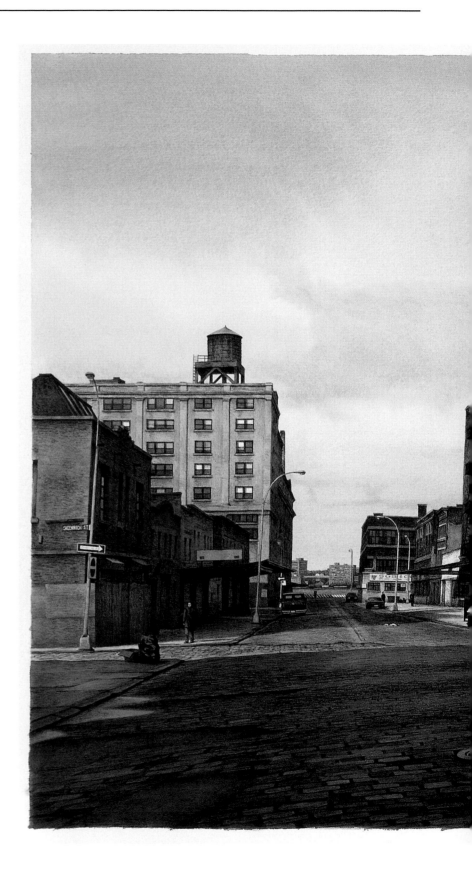

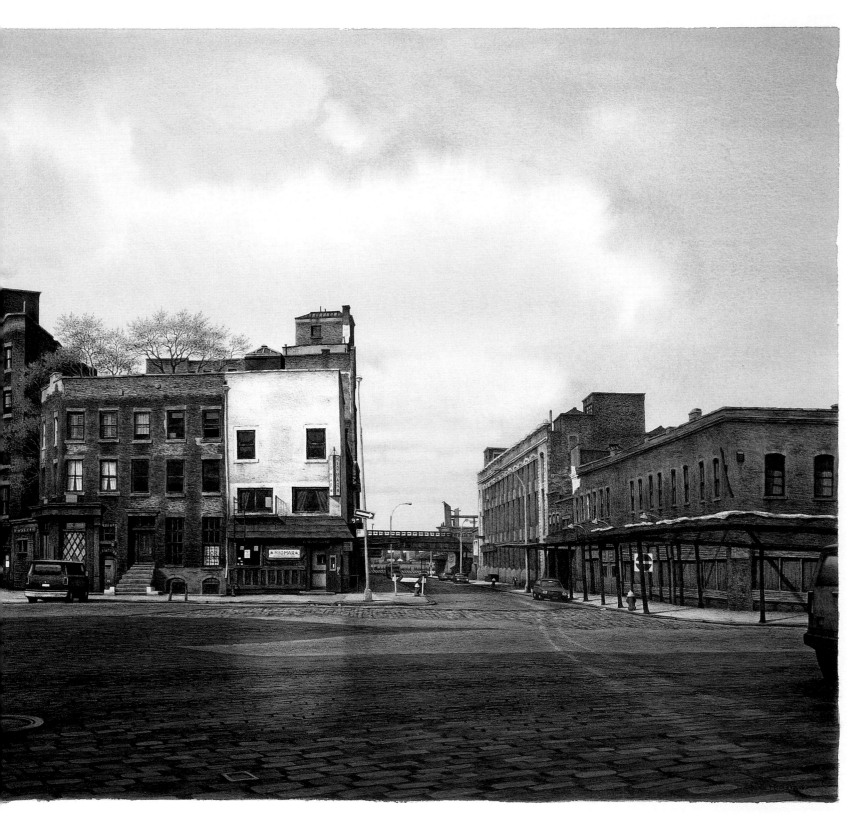

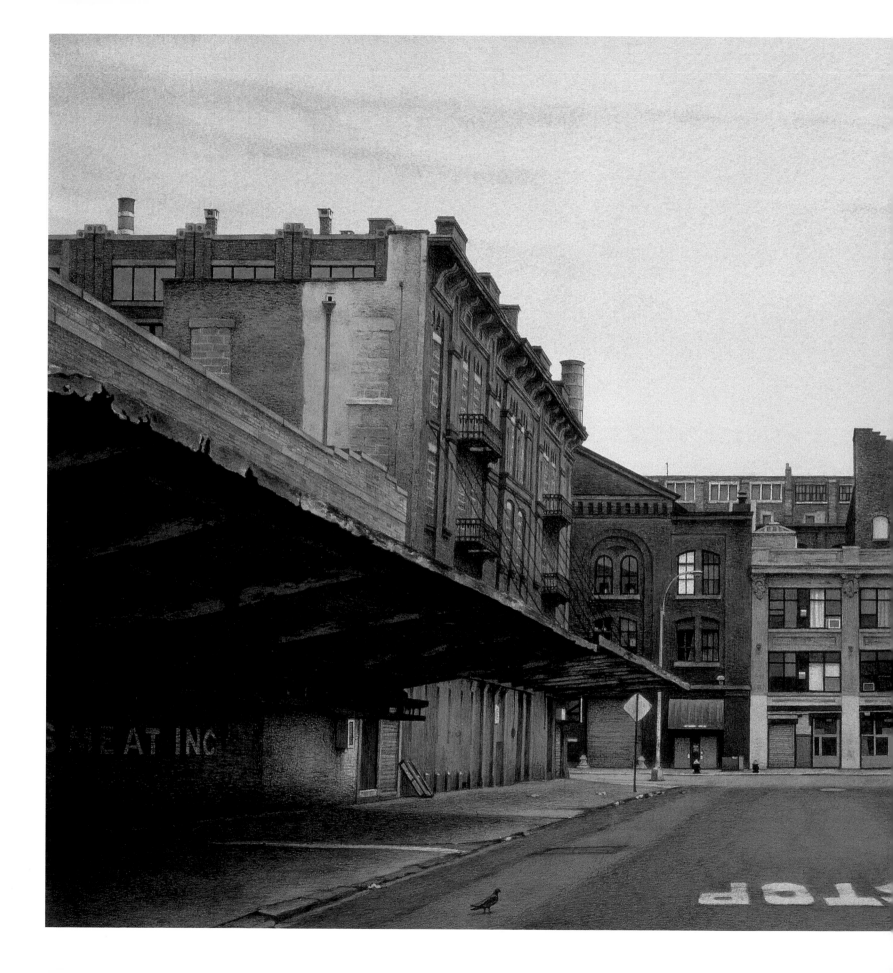

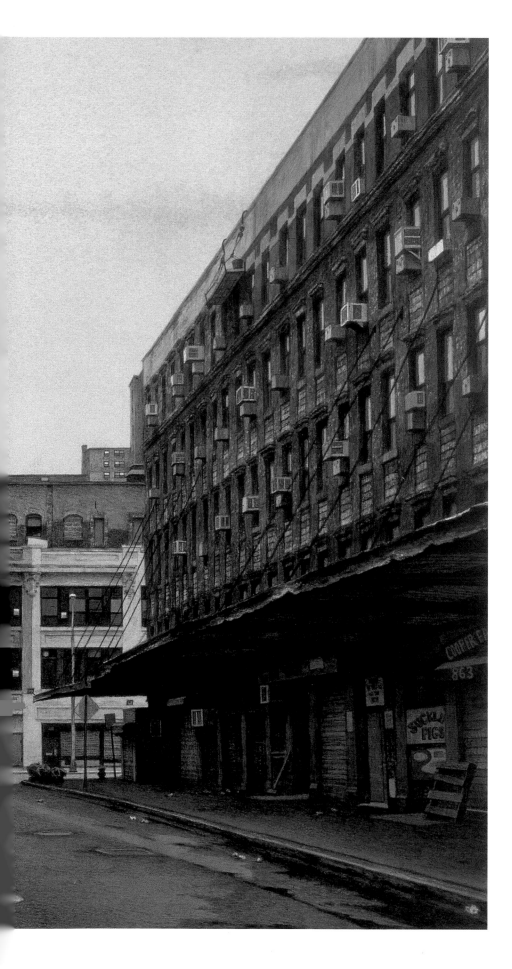

Washington and 14th Street.

The northern end of Washington Street runs into 14th Street, the demarcation line between Greenwich Village to the south and Chelsea to the north. Adjacent to Gansevoort Street, the area is home to old meatpacking plants as well as many thriving and expensive clothing designers, restaurants, and hotels. Until recently, this meat market district had a darker side of late night sex clubs, drugs, and street prostitution. The wide sidewalks and the imposing metal overhangs (where carcasses are hung prior to butchering) still seem ominous in the early morning light.

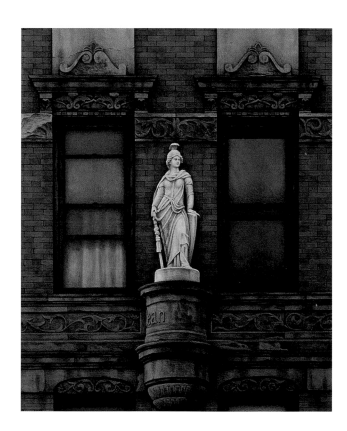

Joan of Arc, 14th Street and Seventh Avenue.

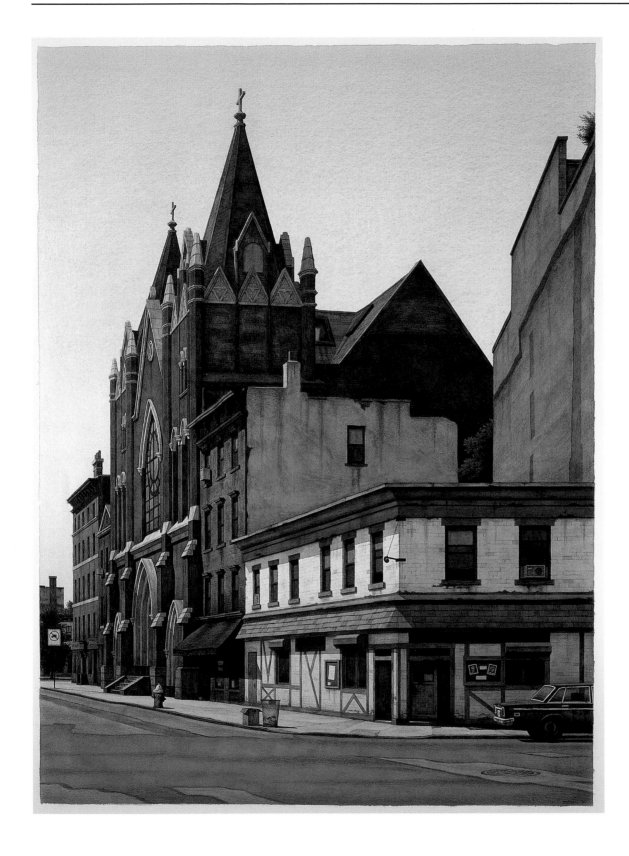

*St. Veronica's Roman Catholic Church,
Christopher Street between Greenwich
and Washington Streets, 1889-90,
John Deer, architect. The austere red
brick facade and thick towers face south
on a wide intersection at the western base
of Christopher Street. The low white
restaurant building affords an open view
of the sidewall of the church's nave.*

St. John's Evangelical Lutheran Church,
originally the Eighth Presbyterian
Church, 81 Christopher Street
1821–31. This mid-block early
19th-century church is topped with an
unusual wooden spire. The early
date and intimate scale give this little
building a striking presence, even amidst
the quaint charms of Greenwich Village.

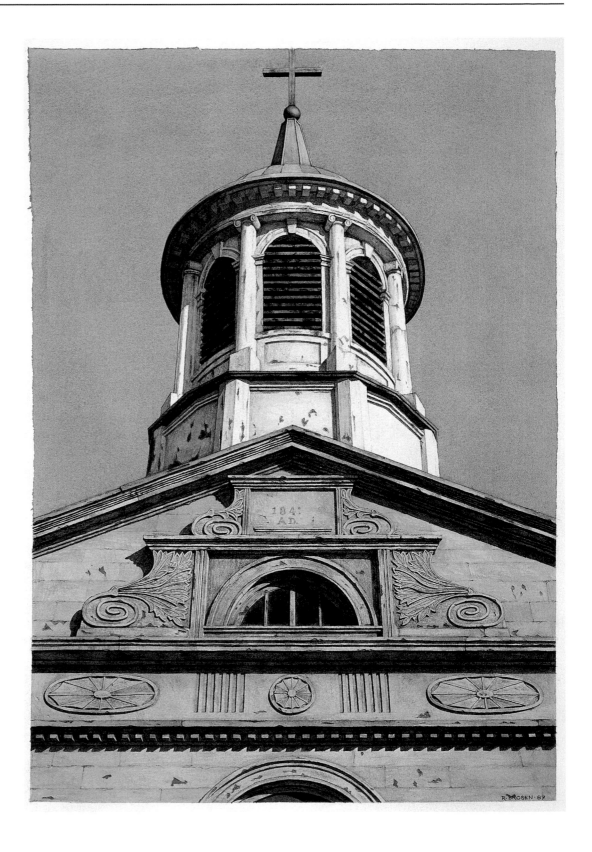

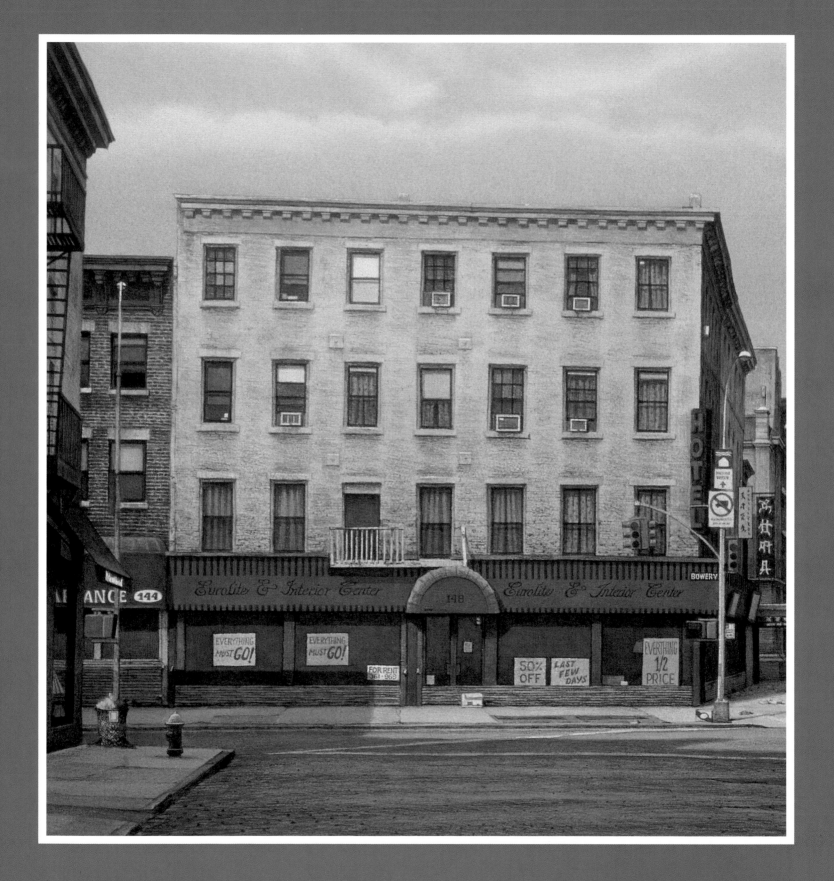

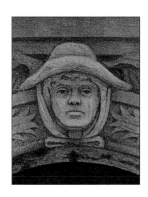

JERRY ALFONSO HAS SPENT THE LAST FIFTY-ONE YEARS living in the Pioneer Hotel on Broome Street and the Bowery. He is the longest continuous resident of New York's longest continuously operating hotel.

"It started as my crash house," Jerry said the other day, opening a cracked palm to indicate the Pioneer's lobby, which he first walked into in 1953. At that point, Jerry was a quartermaster on the LSD Rushmore, a naval landing ship that ferried troops to shore in the Korean War. Whenever he washed up on land, he stayed at the Pioneer.

"Let me tell you, in them days, it was cheap," he said, and, indeed, to hear Jerry's tales of youthful shore leave, when a teenage sailor could drink himself down the sewer for a quarter, stuff his stomach on a dime, then bed down for a dollar a day, one gets the impression that not only has the best of life gone by, but that today's hotels are being run by thieves.

"A room here used to cost you fifty cents a night," he said. "You paid a

Detail from Broome and Bowery, the Pioneer Hotel.

Brooklyn Bridge.
This most celebrated of all New York City's bridges took sixteen years and twenty lives to complete. John Roebling and Washington Roebling, 1867–83, were its visionary engineer/designers. When finished, it was the world's largest suspension bridge, spanning almost 1,600 feet across the East River into Brooklyn, its stone towers rising 135 feet above the water. The pedestrian walkway affords a spectacular panoramic view of the city.

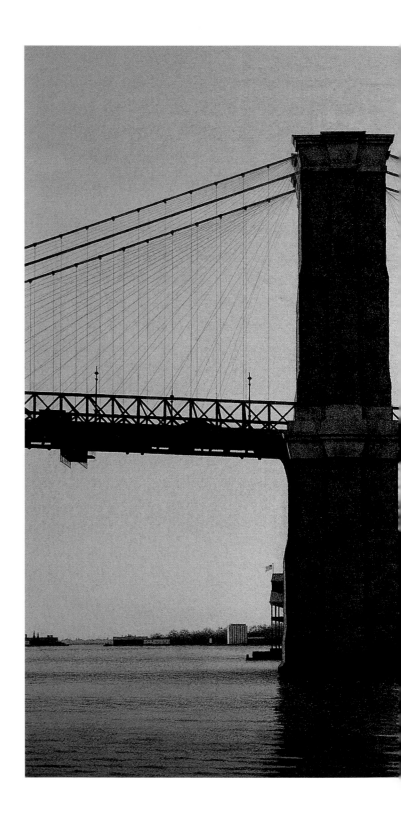

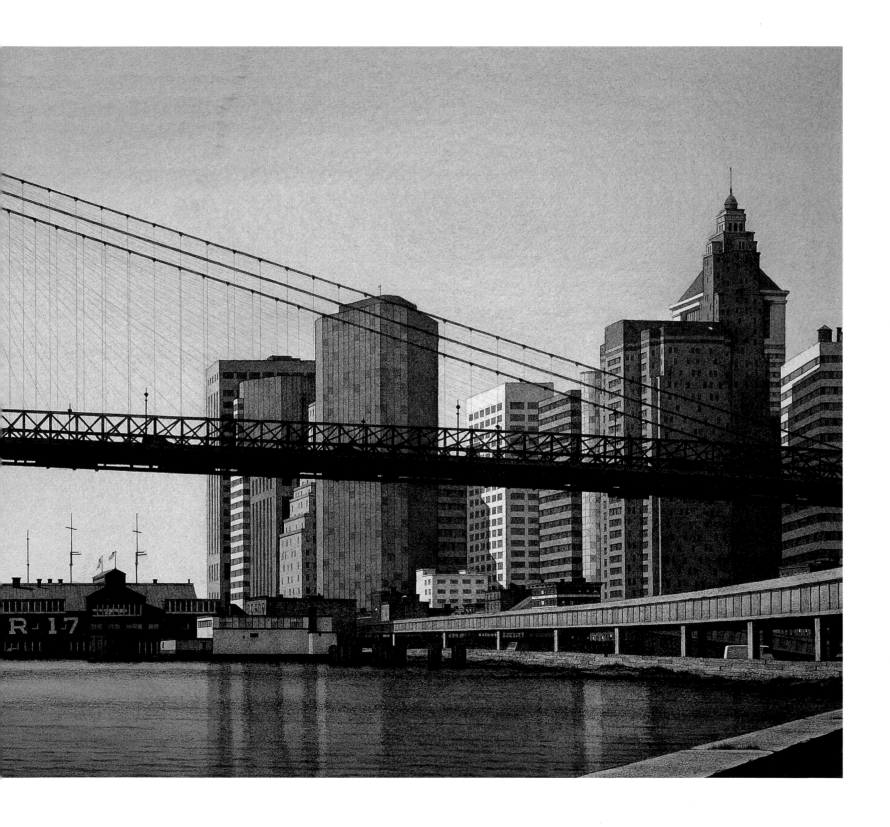

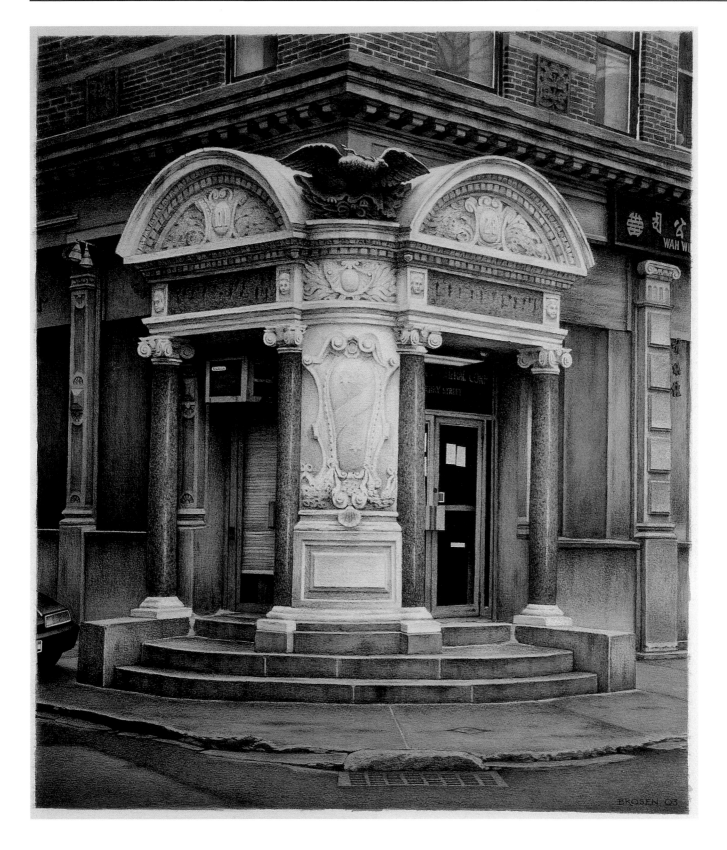

BROSEN 03

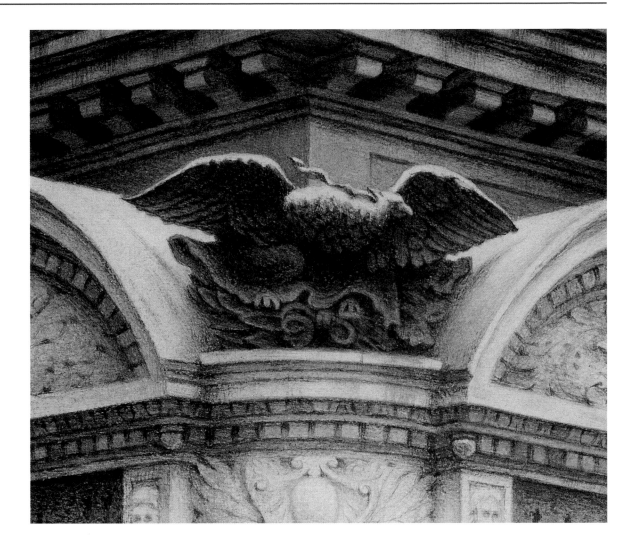

quarter for a bar of soap and a towel. So even if you threw the guy behind the desk a dollar for some extra soap and towels, you still came out ahead."

The Pioneer has always been a haven for wanderers like Jerry. It was built in 1822 as a rest stop for the equestrian set and then served as the chosen home for Union officers en route to fight the Civil War. In the 1870s, doing business as the Occidental, it housed the sandhogs who built the Brooklyn Bridge. At the turn of the century, an upstairs suite became the nighttime headquarters of Big Tim Sullivan, a Tammany boss, whose round-the-clock poker game was so

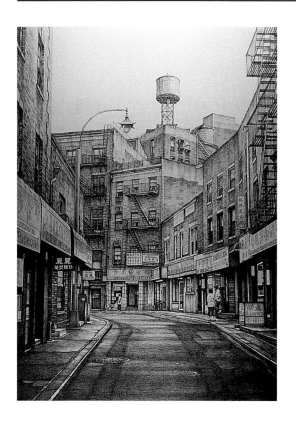

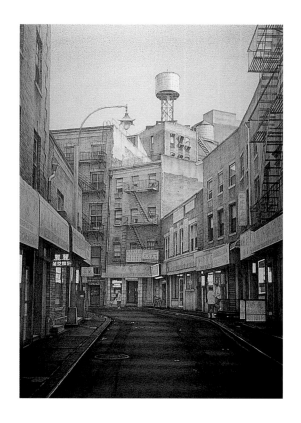

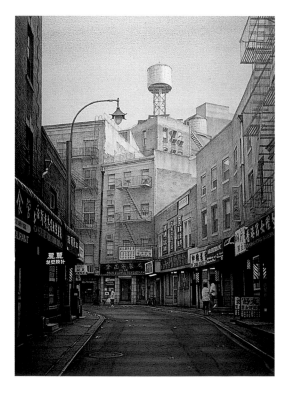

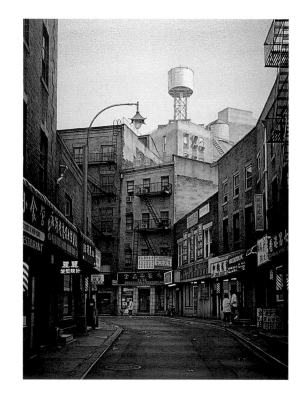

Doyers Street Studies.

Top left: *Initial graphite drawing.*

Top right: *Undertones in blue with street laid in.*

Bottom left: *Stores, signs, and foreground buildings completed.*

Bottom right: *Upper background buildings added.*

Doyers Street.

This street is just one block long with a 90-degree turn in the middle. It is one of the three original blocks that formed Chinatown, along with Mott and Pell. Once called the "Bloody Angle" because of supposed turn-of-the-century Tong wars, it is now home to a large number of barbershops and hairdressers.

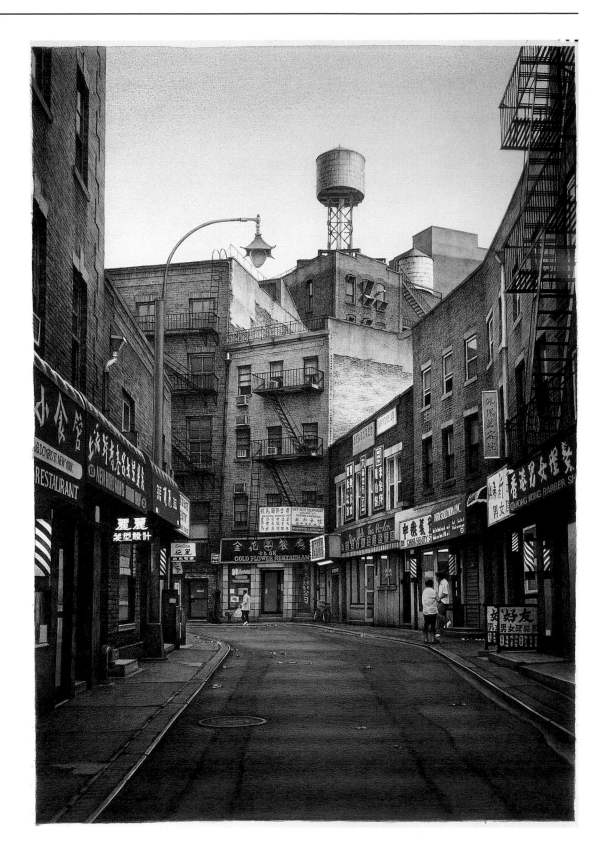

profitable that the dealer alone walked away one year with eighteen-thousand dollars in cash.

Today, the Pioneer still has the gilded seediness of an Old West saloon, and its narrow stairways lurch and lean, as if they too had drunk too much. It is impossible to walk the halls and not imagine voices from a faded era. Even Jerry's voice, a South Bronx rumble, seems to issue from some crevice of the past.

For the last few years, the Pioneer has had a second name, the Sohotel, and the manager is not the Irishman named Ward, as it was in Jerry's day, but a young Hispanic woman who works for the businessman who bought the place. There are Chinese tourists in the lobby and taxis wait outside to whisk the fresh-faced visitors from Germany and Denmark off to the opera and the art museums. Jerry and the fifteen other oldsters who reside there on a permanent basis do not pay the tourists any mind.

"If they make noise, I'll tell 'em, 'Shut up. It's my house.' I sometimes go around with a baseball bat."

At the Pioneer, a baseball bat has always been a wise thing to carry, given that Mr. Ward was from the tougher parishes of Boston and despised all living creatures, it was said, save his old, black cocker spaniel, a bitch named Molly. Like Ward himself, Molly was in constant battle with the clientele, especially Max, the house cat, who, according to Jerry, disappeared under questionable circumstances in the late 1960s and was never seen again.

It may—or may not—be the case that the Pioneer was once owned by a father-and-son team from the Genovese crime family who insured, by dint of reputation, that the amateur oenologists who frequented the place never let their muscadet go to their heads. To this day, Jerry still whispers their name,

Woolworth Building.
Cass Gilbert's extravagant Woolworth Building was the world's tallest when completed in 1913 and remains one of the fifty tallest structures in the United States. The ornate Gothic styling earned it the nickname, "the cathedral of commerce," and F. W. Woolworth, the 5-and-10-cent king, paid $13.5 million for it—in cash. Located on Broadway between Barclay Street and Park Place, it set the aesthetic standard for subsequent generations of skyscrapers and is still one of New York's most beautiful buildings.

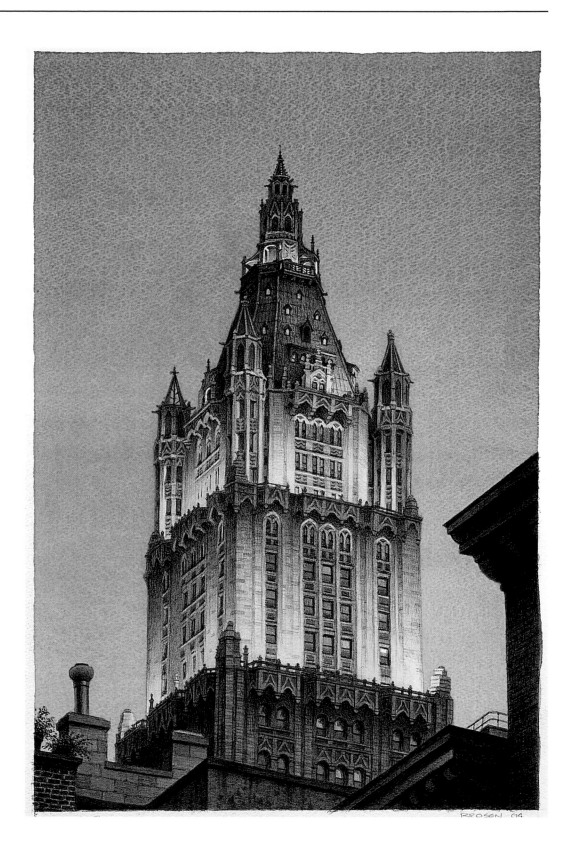

Canal and Centre Streets, View Looking North up Centre Street.

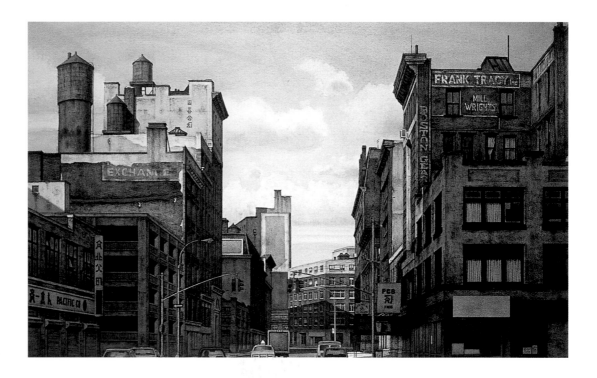

54 Canal Street.
A Roman style cupola once adorned the roof of this late 19th-century office building that was once the home of Jarmulowsky's Bank (est. 1872). The clock and entablature relief sit above the entrance. Today, this corner of Orchard and Canal Streets houses industrious Chinatown workshops.

*Canal and Division Streets.
The right side of this broad view
looks west along Canal Street, a
major east-west street originally an
actual canal used in the beginning
of the 19th century to drain the
heavily polluted Collect Pond. The
street, completed in 1820, separates
SoHo to the north and Tribeca to
the south. Its eastern section once
bordered the notorious Five Points
slum, now the location of several
courthouses in Foley Square.*

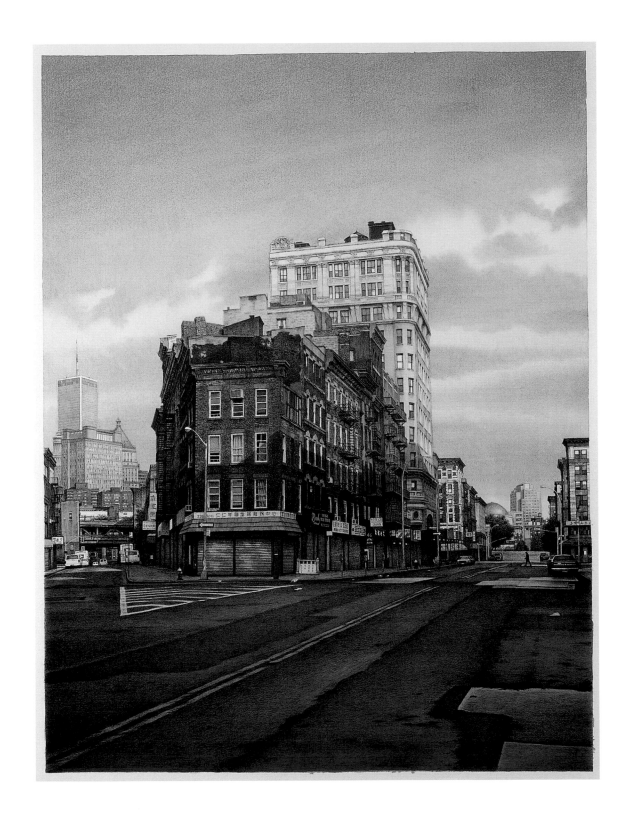

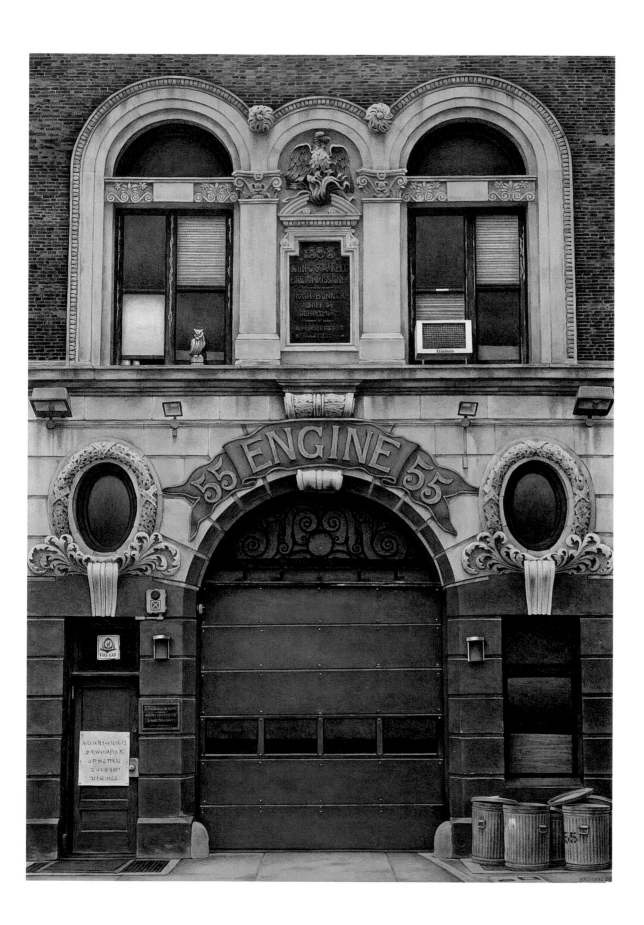

Gallo, noting they were Bronx Gallos, not Brooklyn Gallos, famous for producing Joey Gallo, who was shot to death in 1972 at Umberto's Clam House down the block.

One thing Jerry does admit to is having spoken frequently with John J. Gotti, the Gambino family don, on Gotti's walk-talks through the neighborhood. In the 1980s, Gotti owned a social club, the Ravenite, on Mulberry Street, and Jerry, in a neighborly way, made sure that Gotti felt as welcome on the Bowery as he did downtown.

"He'd be walking around with Sammy the Bull and I'd say, 'Hey, Mr. Gotti how you doing?' And he'd say, 'Who the hell are you?' And I'd say, 'Me? I'm so-and-so from Melrose in the Bronx.'"

Quite possibly, it was these friendly words that helped Jerry get a job each year at the Feast of San Gennaro, a street fair in the neighborhood, which, at one point, was an outdoor trade show for the mob. From 1984 to 1996, Jerry was employed making sure that vendors at the fair did not block the neighborhood's fire hydrants with their stalls.

"Know how many fire hydrants there are on Mulberry from Worth to Houston? Forty-two," he said with pride.

It was during this period, however, that things began to change. First, the drug addicts moved in, Jerry said, and the Fifth Precinct began to send its undercover officers to case the Pioneer.

"I'm talking full-blown stakeouts—guys on the roof with binoculars, helicopters flying overhead."

And with the addicts came the artists, of course.

"We had some artists in the building. No one too famous. Just some guys who painted, you know, painted art. But all that's gone now. All the artists left."

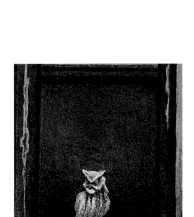

Engine 55, Broome Street. New Yorkers take pride in their firehouses as well as in their firefighters. This richly ornamented one was among the first to be built after the consolidation of greater New York City and has been in continuous operation since. Built in 1898–99, and designed by R.H. Robertson, the building supports a Romanesque facade enlivened with exuberant Beaux-Arts detailing, particularly in the stone-carved company banner. Fresh blue, yellow, and red paint attest to the firefighters affection for the building, as does that time-tested pigeon deterrent, the owl sculpture.

To Jerry, it is crucial that the Pioneer has always been an SRO, a single-room occupancy hotel, and not a flophouse. There is a difference, he explained. In a flophouse, men sleep several to a room in chicken-wire cages. In an SRO it is more humane: one man, one room.

Jerry's room is so compressed with fifty years of clutter that he cannot fully open the door. He slips in sideways, shoulders first. Inside, there is so little room that his back is pressed against an avalanche of boxes even as his knees press up against the bed.

The boxes run from floor to ceiling. They are filled with the baseball box scores Jerry has collected since 1984. One wall shows a map of the world; another, a front page of *The New York Post* announcing Cardinal O'Connor's death. Jerry's bed is a navy bed—a wool blanket folded tightly over crisp white sheets. At the edge of the bed, two television sets are stacked up one atop the other. He says, by way of explanation, "Let's say there's two games on at once...."

It is here that Jerry spends his days, flipping through the papers, watching baseball, keeping box scores, fighting with the management over pillows, sheets, and towels. Half a century has passed in just this way. At seventy-two, however, Jerry knows there will not be half a century more.

"A rattrap is what this is," Jerry said. "But it's my rattrap. Where else is a guy like me supposed to go?"

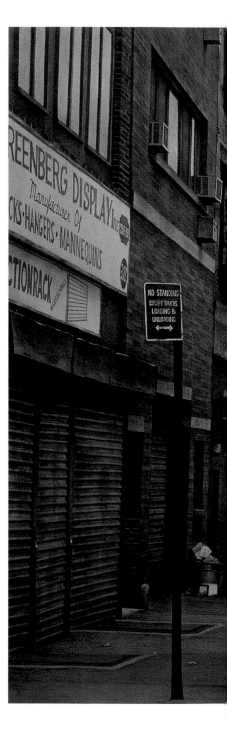

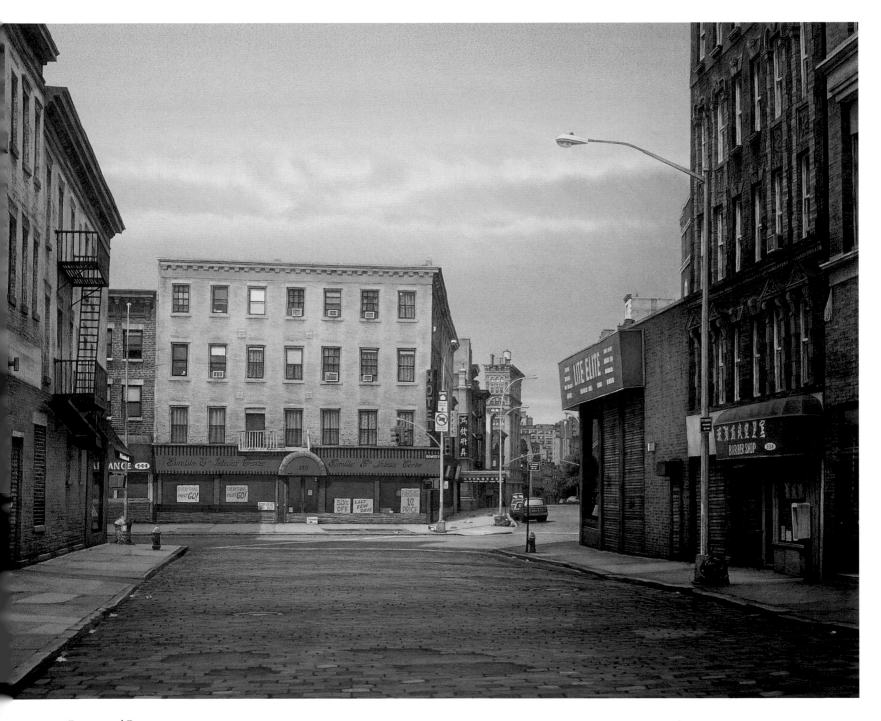

Broome and Bowery.

The Pioneer Hotel is the oldest continually operating hotel in New York City. When it opened in the beginning of the 1800s, it offered discounts to Revolutionary War veterans. The hotel extends a full avenue block along Broome Street. Inside, the long hallways are floored with wide, warped planks, and gas lamp spigots are still affixed to the walls.

Today the hotel caters mostly to young, budget-minded Europeans. A walk west from here along Broome Street provides a rich architectural tour of old New York, past the tenements of the Lower East Side, across the more fashionable Lafayette Street, and on into SoHo.

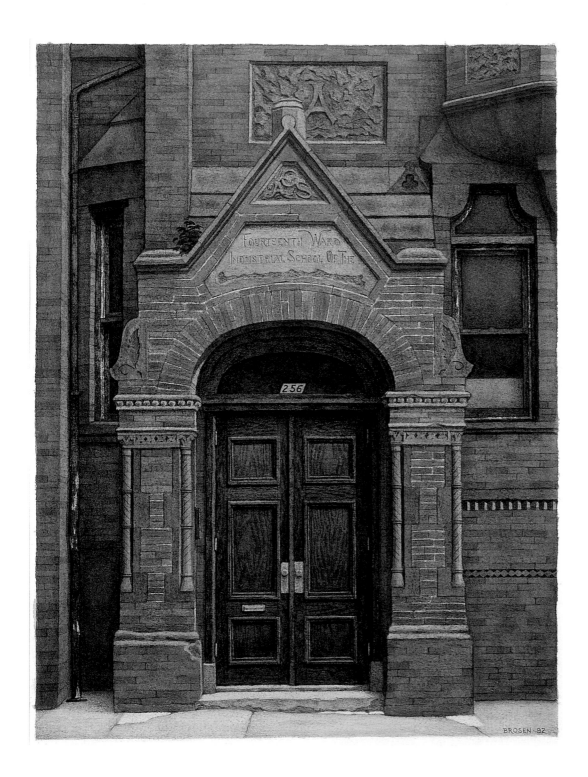

BROSEN · 92

OPPOSITE: *Mulberry and Prince Streets. Old St. Patrick's Cathedral is one of the oldest ecclesiastical structures in New York. Construction began in 1809, was halted during the war of 1812, and completed in 1815. This area, in the eastern section of SoHo, is filled with small bistros, cafes, and designer boutiques, yet retains many remains of 19th-century New York. The wall of St. Patrick's Cemetery runs along Prince Street (note the single obelisk), and beyond the cathedral along Mulberry Street stands St. Michael's Chapel (1858). Unseen in this painting and across the street are an 1826 parochial school and one of the original Children's Aid Society buildings.*

Fourteenth Ward Industrial School. This Children's Aid Society building (the CAS initials can still be seen carved above the door) at 256-258 Mott Street stands across the street from old St. Patrick's Cathedral. Built as a school for indigent children in 1888-89, it is one of several such schools designed by Vaux and Radford with funds provided by John Jacob Astor. The Victorian Gothic building served as a school until 1913 and is now cooperative apartments.

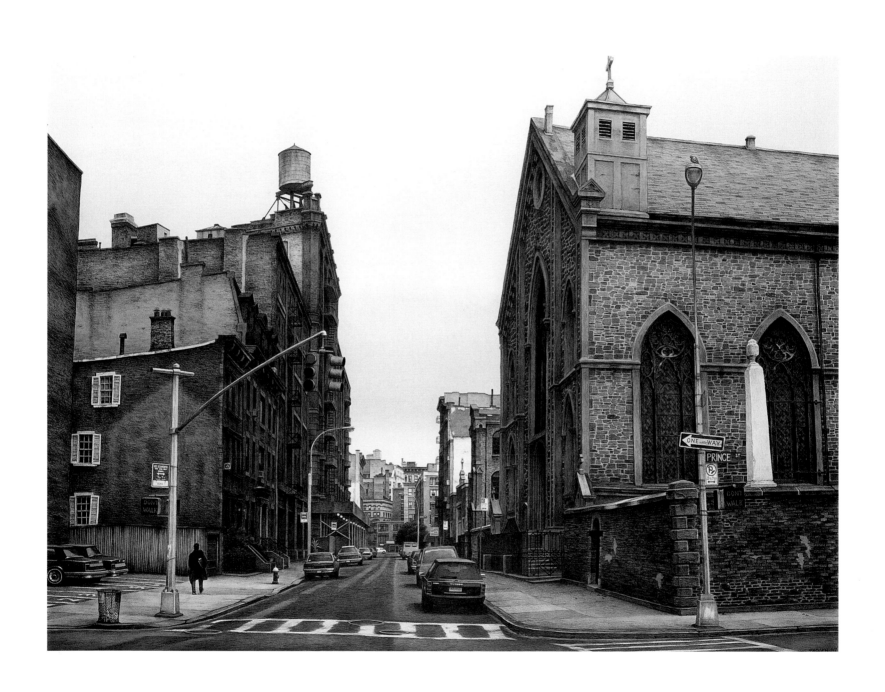

Bond Street.

Bond Street was built as a commercial thoroughfare, wide enough to accommodate several rows of horse-drawn wagons transporting goods. The buildings on the left still show their original mixed-use design, a shop on the ground floor, manufacture and production on the second, and family home upstairs.

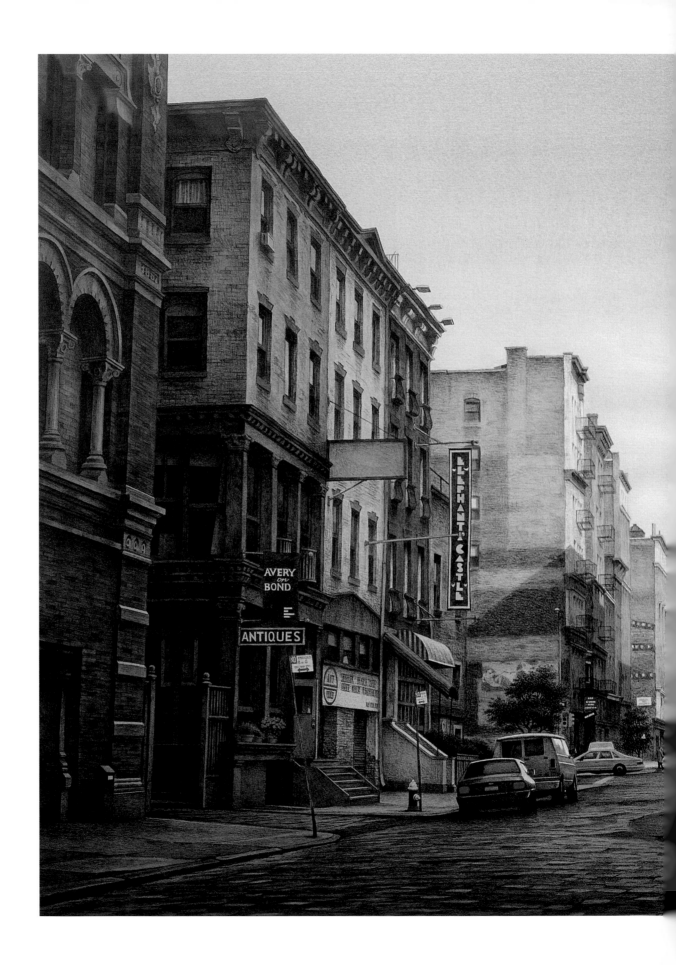

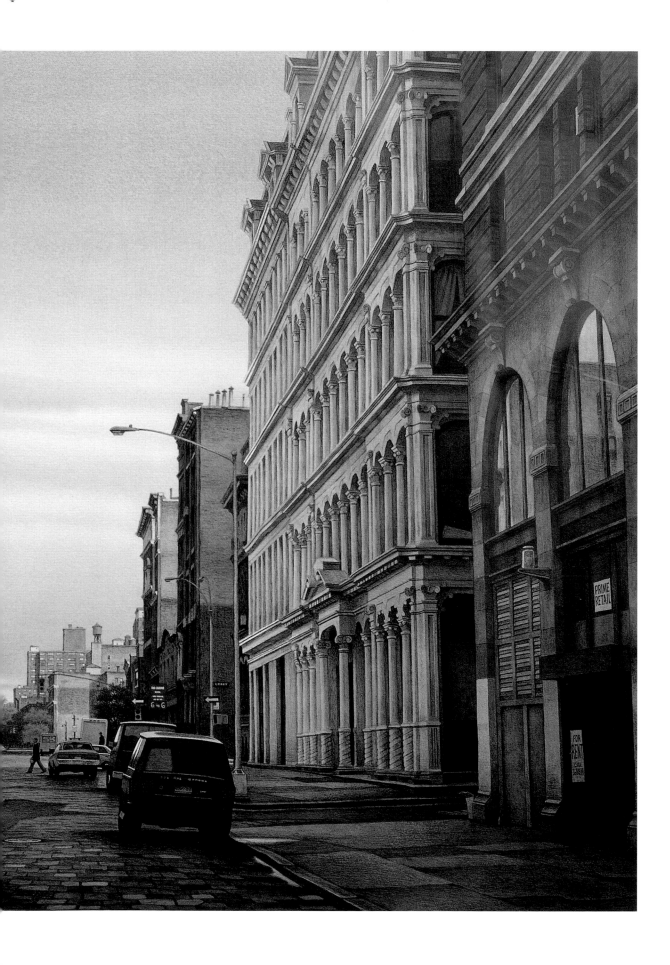

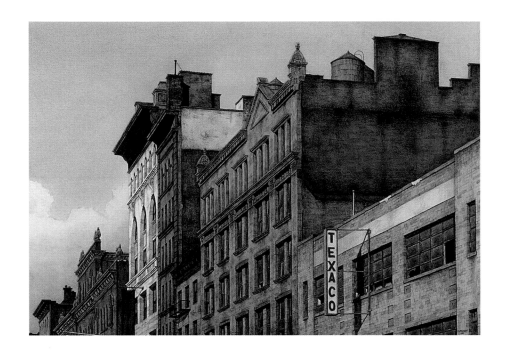

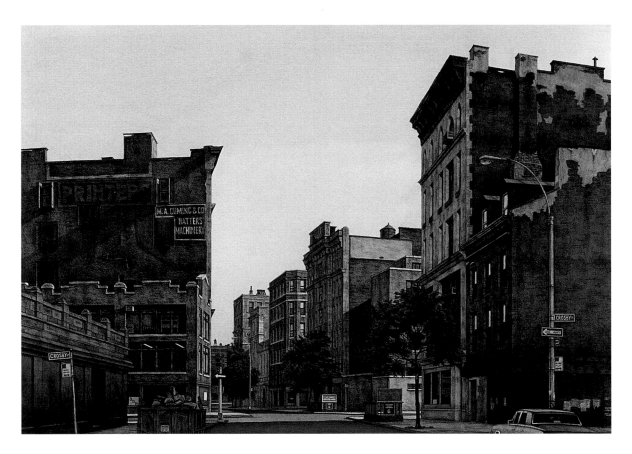

Temperance Foundation, Tompkins Square Park.

Tompkins Square Park extends from Avenue A to Avenue B between 7th and 10th streets. At its center is an elaborate drinking fountain, an 1888 gift of the philanthropist Henry D. Cogswell. His generosity was inspired by the 19th-century anti-alcohol Temperance Movement in an effort to encourage the local populace to drink the free water rather than whiskey. Atop the fountain stands Hebe, mythical water carrier, surrounded by the words Faith, Hope, Charity, and Temperance. The sculpture today is a 1992 bronze copy of the original zinc figure, which itself was a replica of one made of marble by the great Danish sculptor Albert Thorvaldsen.

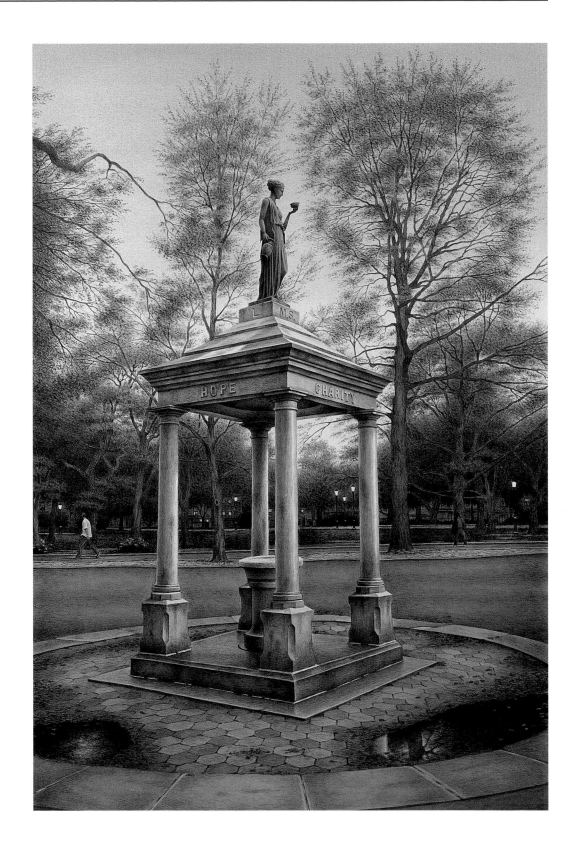

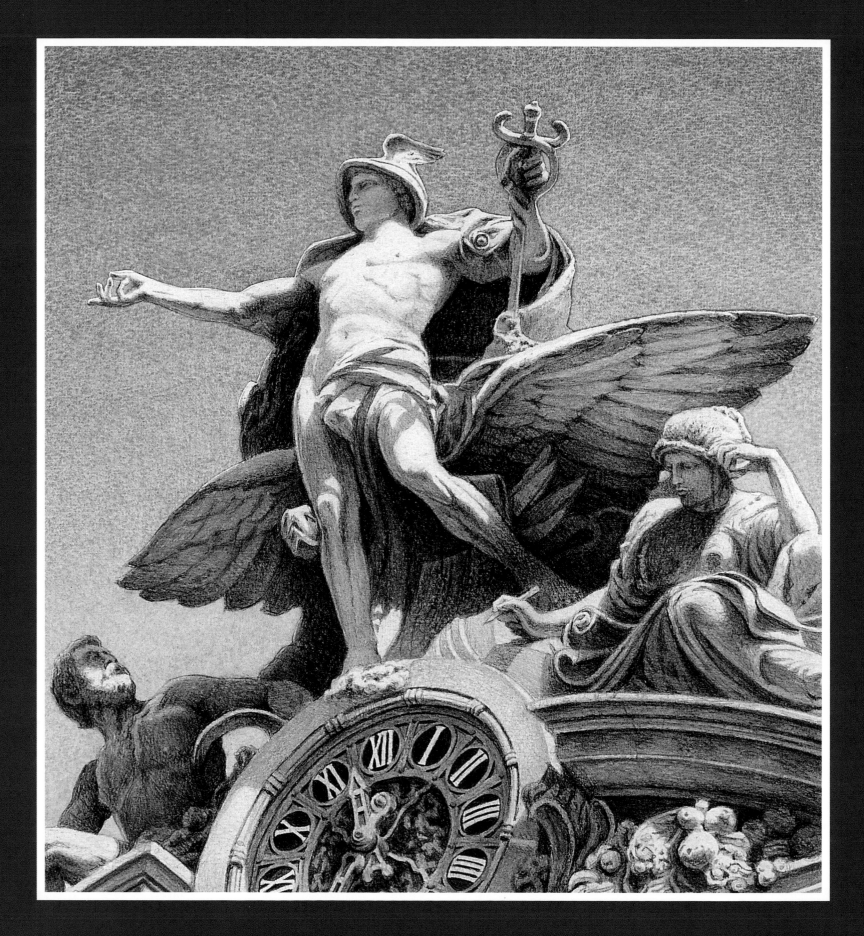

WHEN VALERIE STEGMAYER PICKS UP THE PHONE, IT IS likely a pensioner from Peekskill calling to ask why rabbits' feet are lucky, or a West Side teacher needing the precipitation rate in Spain, or else a school kid from Canarsie who simply wonders what the sparrows at his window might be saying when they sing.

Ms. Stegmayer is an information assistant for the New York Public Library's telephone reference line, a job that entails sitting several hours a day inside a small office at Thirty-ninth Street and Fifth Avenue, fielding arcane questions from the people of New York. New Yorkers are a curious lot, and, over the years, Ms. Stegmayer has done her best to respond to questions that have ranged from "What is greed?" and "Where was Byzantium?" to "Who invented dental floss?" She has settled more bets than she can remember and has, no doubt, helped forgetful souls tortured by a midday lapse of memory to retrieve their peace of mind. A few years ago, she took a call from a worried boy

Detail of Mercury at Grand Central Station.

who wanted to know if certain bodily practices were "bad." Ms. Stegmayer told him to ask his school nurse—or failing that, a priest.

"To me the fun is in the hunt," she said the other day, sitting at her desk beside a bookshelf crammed with almanacs and heavy tomes of quotes. Her office, on the second floor of the Mid-Manhattan Library, catercorner to the main library, is cluttered with at least a thousand books. There are the obvious choices—*Rare Mammals of the World*, for instance, or *The Biographical Encyclopedia of Jazz*. But then there are the rarer volumes—*The Spice and Herb Bible* by Ian Hemphill or H E. Goldin's *Dictionary of Underworld Slang*.

The main library sits in the geographic center of New York, on Fifth Avenue between Forty-first and Forty-second Streets. It was a stroke of fortune that the city's elders built a temple to the book in the heart of Midtown, equidistant from the grandeur of Grand Central Station and the neon crudity of Times Square. A contract was struck in 1895 between the estate of Samuel Tilden, a former governor of New York, and the Astor and Lenox families to build the structure, which took more than sixteen years and nine-million dollars to complete. When the library opened on May 24, 1911, fifty-thousand visitors streamed up its marble stairs. One of the first items called for was N. I. Grot's *Ethical Ideas of Our Time*, an obscure study of Friedrich Nietzsche and Leo Tolstoy. The reader turned his slip in at 9:08 in the morning. The staff was so efficient, so the story goes, he got the book at 9:14 A.M.

Today, the library is perhaps best known for the two marble lions that guard its doors and that were named Patience and Fortitude by Mayor Fiorello LaGuardia in the 1930s. Ms. Stegmayer knows this fact because she has been asked for it at least a hundred times. Her telephone is open to the public Monday through Saturday, from nine in the morning until six at night, and,

Lion, New York Public Library.
Between 42nd and 41st Streets, two dignified marble lions keep watch at the Fifth Avenue entrance to the New York Public Library. This grand Beaux-Arts building, designed by Carrere and Hastings was completed in 1911 when E.C. Porter sculpted the now famous guardians, Patience and Fortitude. This lion, Patience, rests at the south side of the building, silhouetted in shade against the massive sunlit marble of the library's imposing facade.

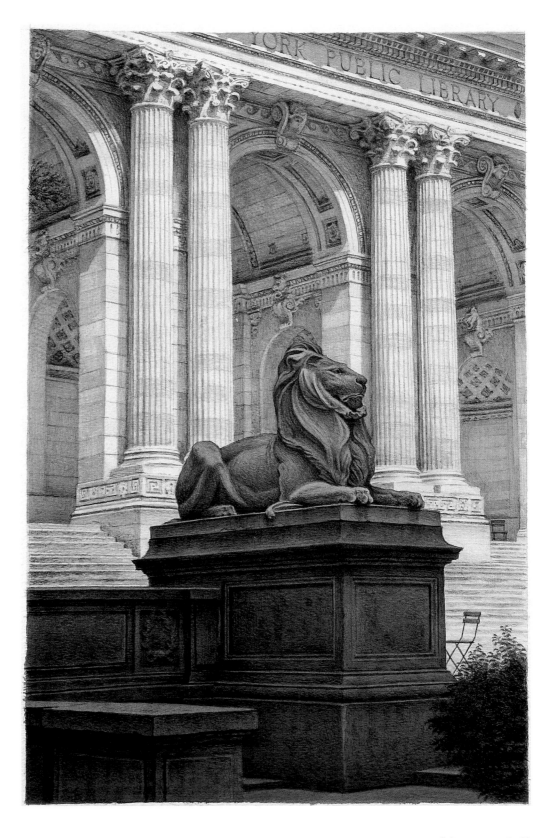

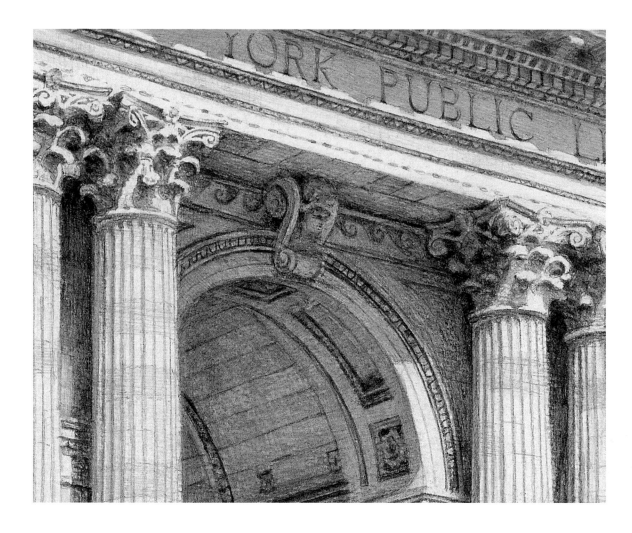

most days, she and her colleagues receive two-hundred separate inquiries, down considerably from the eight hundred they received just fifteen years ago.

The flow of information passing through her brain would overwhelm most people, but not Ms. Stegmayer, who says she can never quite recall the facts and figures she looks up for other people on the phone. "My husband, Rudy, says, 'Valerie? She's knows everything,'"—not true, she claims. Her friends assume she is a wizard at games like Trivial Pursuit—not so, she says. Ms. Stegmayer can ferret out the name of Peru's vice president in thirty-seven seconds, but it is not the sort of thing she wants inside her brain.

For difficult calls, she and the other informational assistants keep a "hard-to-find" file—an ordinary cabinet of ordinary note cards filled with extraordinary facts. "We've got the hottest and coldest days on record," she said, flipping through a drawer. There are cards for the Seven Hills of Rome, female army generals, types of Arab pants, and New York blackouts. And a whole file on presidential pets.

To remain current, Ms. Stegmayer culls the papers every morning for new and exciting bits of data. She might read a story on a new moon orbiting Jupiter, or a home-run record broken, or a state school in Alaska that has gone and changed its dean. She is particularly vigilant with the obituary columns. When a famous person dies, she opens *Who's Who*, or another celebrity index, and writes the person's birth and death dates there beside the name.

Her tiny desk in Midtown radiates with knowledge, and it sometimes feels as if she sits at the center of a questioning metropolis, hungry for the answers she alone can provide. This is never more the case then when a regular caller, a man named Morris, phones from the veterans' hospital in Brooklyn twice a week. "Can a sociopath be nice?" Morris asks from his pay phone. "What does the devil have to be thankful for?" "What is good?" "What is evil?" "What does it mean to *feel*?"

Surrounded by her books, Ms. Stegmayer does what she can. "Usually, we read him definitions from the dictionary," she explains—but before she can continue, the telephone rings and she is on to another call, another question, and another hungry mind.

OPPOSITE: *Rutherford Place.*
Rutherford Place extends two blocks between 15th and 17th Streets. This view looking north from 16th Street features the Greek Revival Friends Meeting House on the left (1861), followed by the Romanesque style St. George's Church (1846–56). Detail of tower below.

MacIntyre Building.
Here at Broadway and 18th Street, R. H. Robertson's 1892 loft building rises over the north side of Union Square Park. Another contribution of architecture's "Gilded Age," it is a fanciful composite of decorative elements—crenelated, oxidized detailing, stone carvings, pitched tile roof, and deep bay windows.

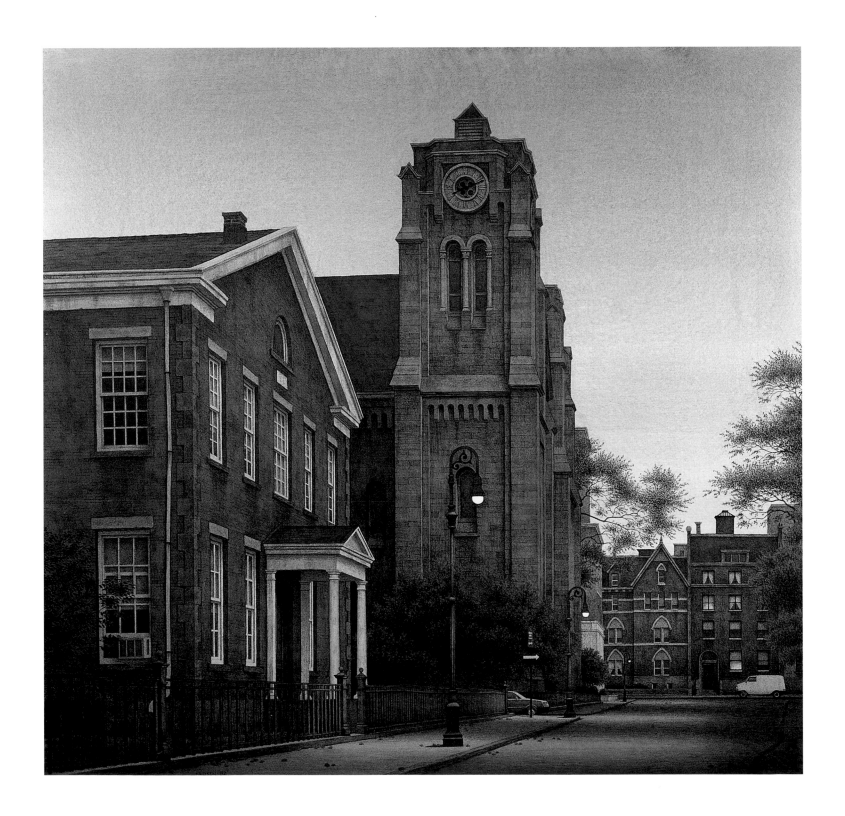

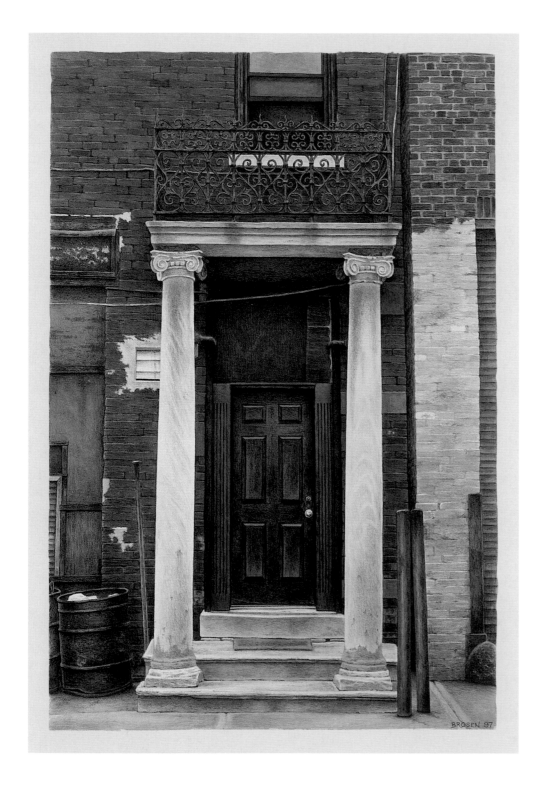

559 West 22nd Street.
An unobtrusive four-story building near Eleventh Avenue,
559, illustrates the poignant story of urban gentrification.
The lower two stories of this century-old S.R.O.(Single
Room Occupancy) Hotel are now a ground floor café and
second floor art gallery. Up the wooden stairway, down the
wide-plank halls, are tiny, kitchen-less rooms and one
communal bathroom per floor for the remaining long-term
residents. Many of the rooms are padlocked, and the
building appears to have been recently sold, ensuring its
continuing transformation.

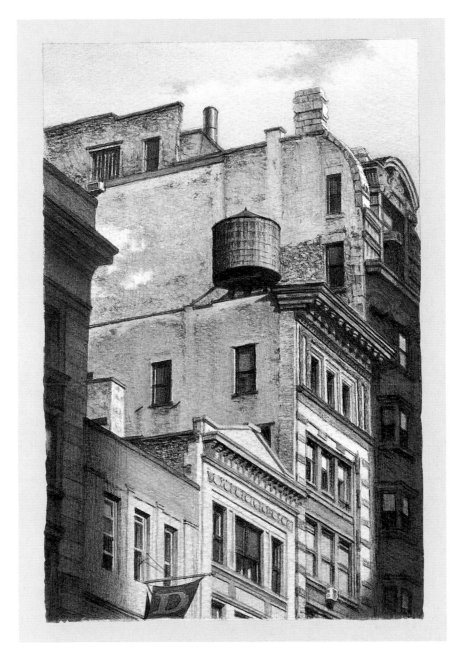

Fifth Avenue between 25th and 26th Streets.
This 19th-century grouping beyond the north end of Madison Square
retains its original look on the upper stories. Like many buildings
within the once elegant shopping stretch along Ladies Mile, the
ground level shops have been substantially altered over time.

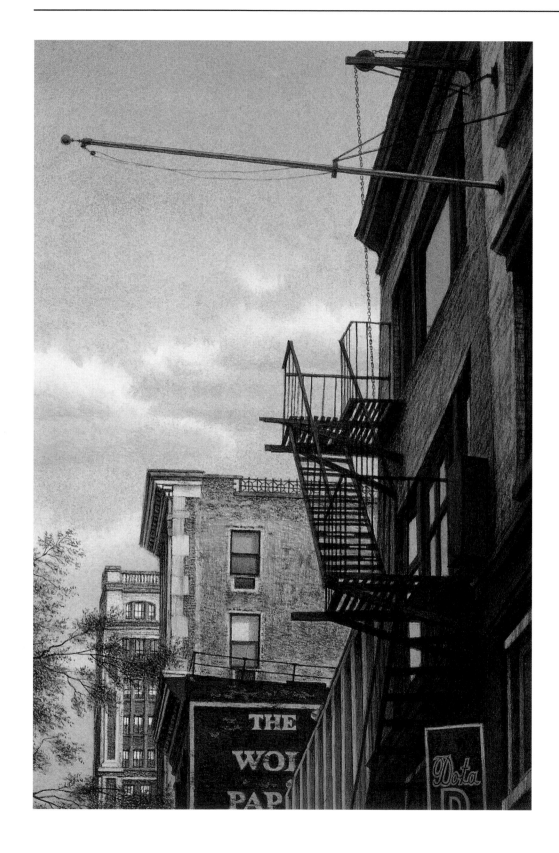

Sixth Avenue from 22nd Street.
This view looking north up Sixth Avenue focuses on the faded bricks and cornices of these 19th-century shop buildings, once part of the elegant Ladies Mile. The ground levels have all been substantially altered by the current variety of commercial venues, leaving the original integrity of the architecture visible only on the upper stories.

Opposite: Broadway from 21st Street, Looking North.
The row of mid-19th-century buildings is a reminder of the genteel era of the Ladies Mile, when this stretch of Broadway was filled with fashionable department stores and refined specialty shops. The building at the right, whose yellow wall rises above the lower structures, was once the Glenham Hotel built in 1861–62, which provided an elegant rest stop after a day of local shopping.

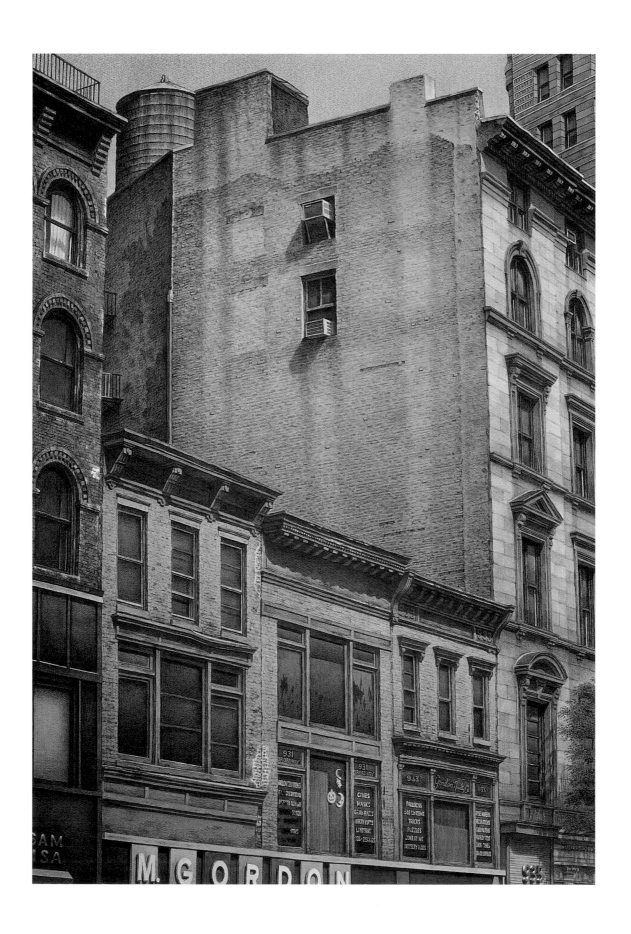

Midtown Studies.

ABOVE: *MacIntyre Building, Broadway and 18th Street.*
RIGHT: *From Sixth Avenue.*
OPPOSITE, TOP: *Rooftops, West 20s.*
OPPOSITE, BOTTOM: *Broadway and 28th Street.*

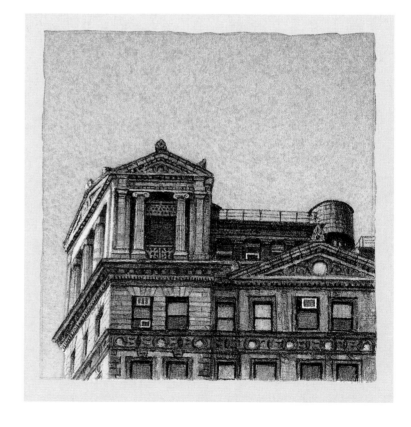

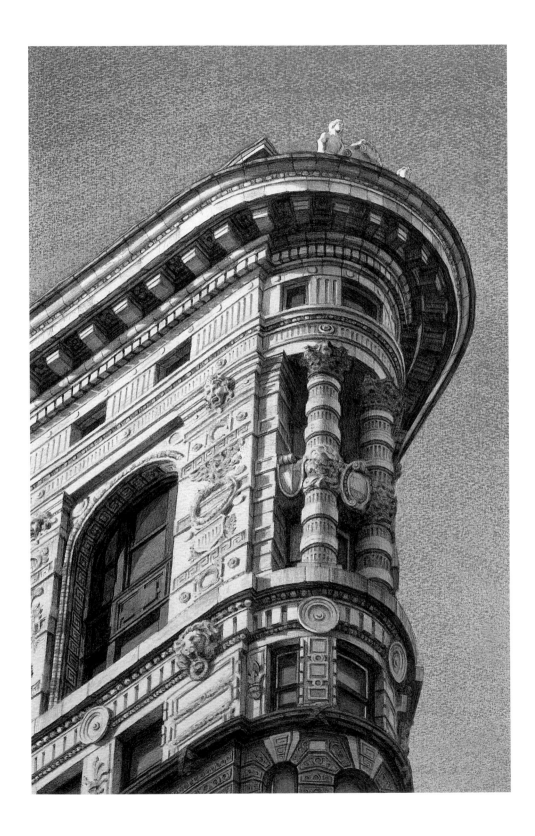

Fuller Building (Flatiron Building).
Daniel H. Burnham's 1902 Fuller Building was
immediately dubbed the Flatiron Building owing
to its unusual triangular shape, a mere six feet
wide at the apex. Situated at 23rd Street between
Broadway and Fifth Avenue, the solitary tower
rises gracefully over the southern end of Madison
Square Park and has been the subject of many
classic photographs and paintings of the city.
Detail opposite page.

West 25th Street.

Looking east from Tenth Avenue, this western Chelsea scene captures the early days of the area's conversion from storage and light manufacturing to fashionable galleries and hip restaurants. The elevated tracks of the High Line Railroad, which transported goods from Chelsea to the 30th Street freight yards, can be seen in the middle distance.

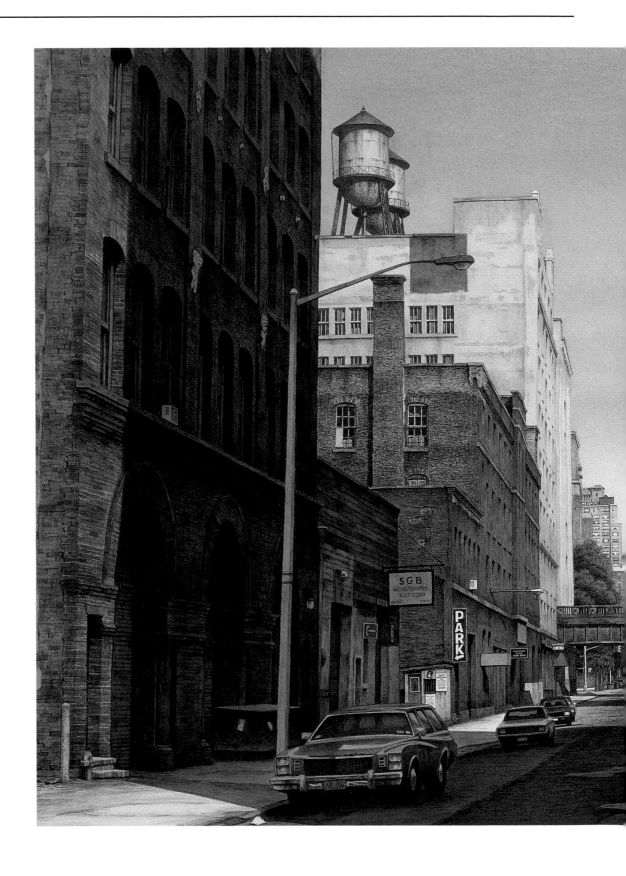

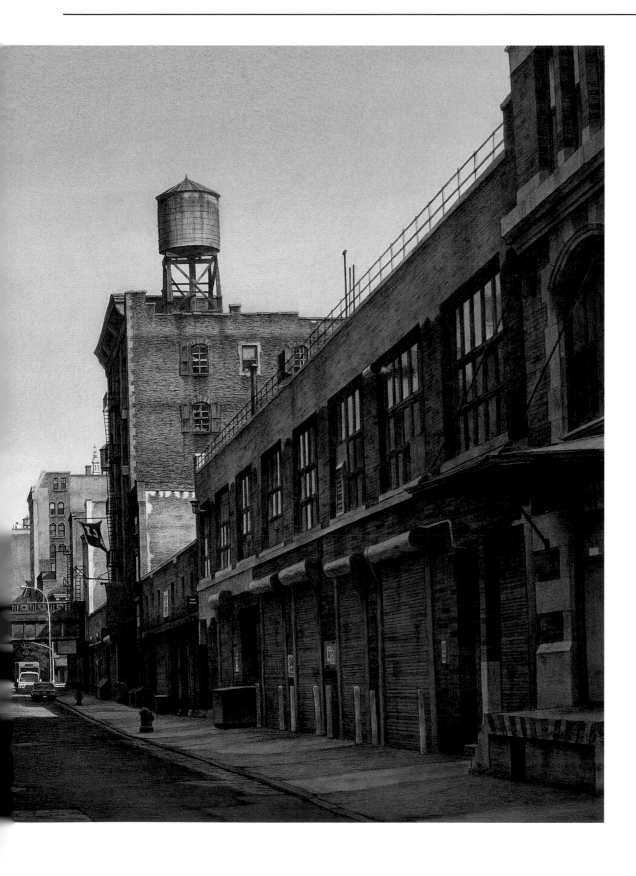

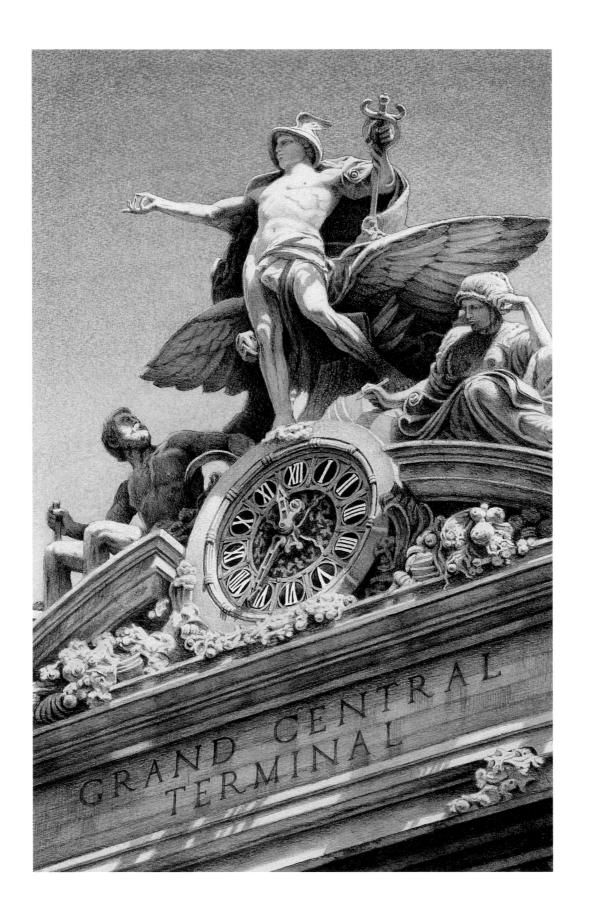

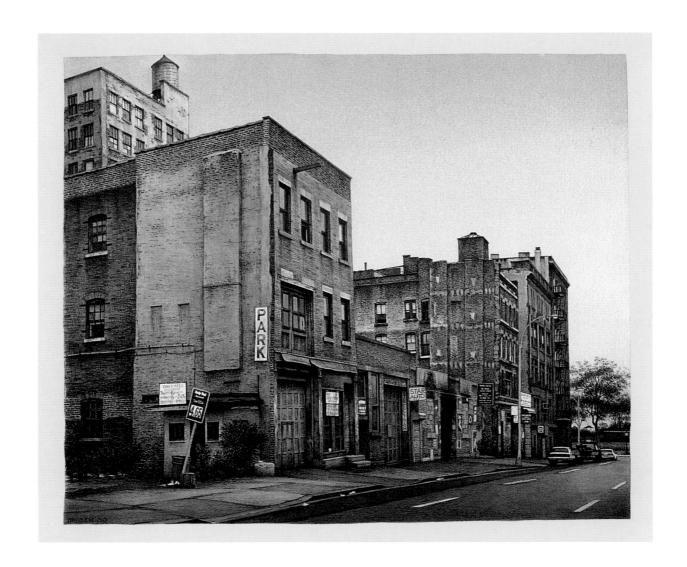

OPPOSITE: *Grand Central Terminal.*

Jules-Alexis Coutan's monumental sculptural grouping, Transportation, *sits atop the main entrance to Grand Central Terminal, where it has greeted millions of commuters every day since 1913. The reclining figures of Hercules and Minerva flank Mercury, standing at the center twenty-nine feet tall. Coutan modeled the group in clay in Paris and they were carved at the William Bradley stone yards in Long Island City.*

West 53rd Street.

Small pockets of Hell's Kitchen's hardscrabble working class history can still be found on isolated side streets near Dewitt Clinton Park. The scruffy beauty, textures, and patterns of these low, buff colored brick apartment houses and automotive repair shops are endangered as development pressures make demolition inevitable. As further evidence of gentrification, the area now goes by the trendier name of Clinton.

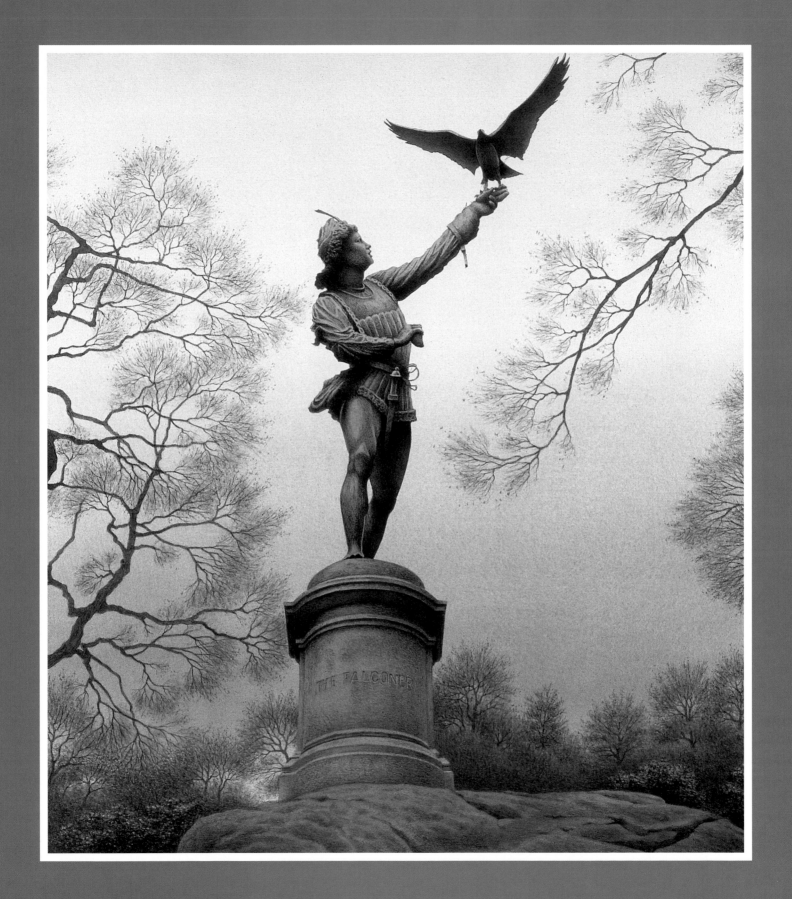

 ONE CAN SAFELY SAY THAT NICE AND PLEASANT ARE words not typically associated with New York. It might be possible to spend an entire season in the city and never come across a person, place, or thing described by either one. Adjectivally, of course, nice and pleasant are more descriptive of the suburbs than the city—the suburbs being home to inoffensive nouns like sparrows, elm trees, ants, accountants, and Labor Day parades. They are also useful in discussions of the country and of certain towns in Europe. (A hay ride through the pines is nice about the same way a week in Paris might be pleasant.) In New York, however, soft-edged modifiers don't apply. Here the air is bracing; the citizens, flinty; the architecture, towering. Even the streets, if one believes the old saw, are decidedly mean.

Sal Napolitano, who operates the carousel in Central Park, is nonetheless one of the nicest and most pleasant people one could ever meet. He is that rarity in New York—a genuinely good man who is neither a failure nor a dope.

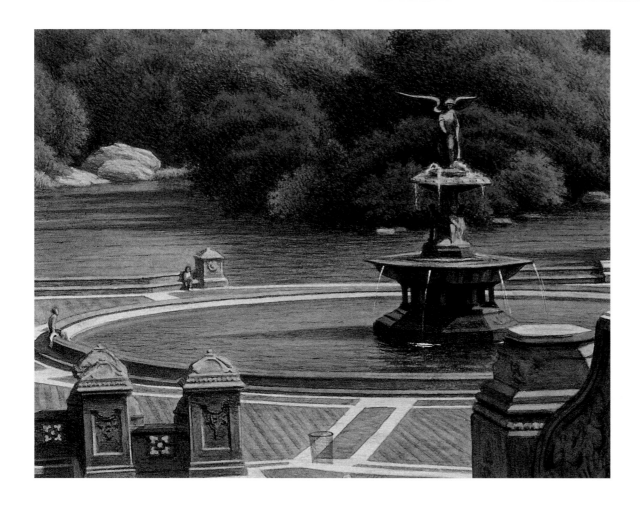

"What can I say—I love my job," he remarked the other day, briefly breaking from the work of varnishing fifty-seven basswood stallions, which along with two wood chariots, form the public parts of his machine. "I enjoy coming to the park. I enjoy the change of the seasons. If you find something you would do for nothing, hey, that's half the battle."

In all aspects of his life, aside from his vocation, Mr. Napolitano—born, raised, and still living in the Throg's Neck section of the Bronx—is extraordinarily ordinary. He is neither rich nor poor, neither underschooled nor overschooled. He is not timid, but not bombastic either, and he seems to enjoy his fellow man while maintaining a private sense of self. Physically, he is

Bethesda Fountain Terrace. This wide and graceful stairway is one of a pair flanking the western and eastern sides of the Bethesda Fountain esplanade. It took five years, 1868-73, for Jacob Wrey Mould to execute the intricate stairway carvings, mixing geometric patterns with vignettes of flora and fauna indigenous to the park. Calvert Vaux's grand terrace design leads down the mall to this vista from 72nd Street Drive, one of the most beautiful in Central Park.

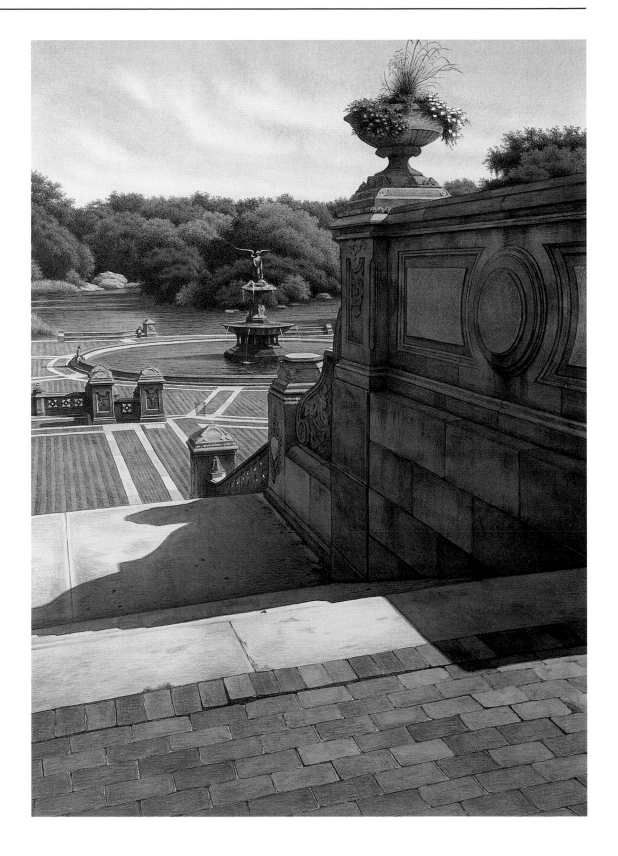

unremarkable—a male specimen of average height and build, not too heavy, not too light, and with a plain complexion, a sandy head of hair atop of which often sits a baseball cap, and a taste for tennis shoes and jeans. He is, by nature, unassuming and would clearly make the ideal neighbor. And at fifty years old, he is almost exactly middle-aged.

How, then, to explain the outsized passion he harbors for the carousel, which has stood at the revolving center of his life for the last thirty-five years? At fifteen, Mr. Napolitano started out taking tickets and strapping toddlers onto horses. In the years that followed, he rose to operate the thing. He promises to do so until the day he finally dies.

"A carousel never loses its charm," he said. "A rollercoaster is a thrill ride, but a carousel is a fantasy ride. You use your imagination. With the horses, you can be a knight, a cowboy, an Indian, a princess—whatever you want. In the high-pressure atmosphere of Manhattan, people need a place to escape. And what better place to escape than a carousel?" he asked.

Mr. Napolitano's own imagination is invested so deeply in the carousel there seems no difference between his life and its own. He not only cares for its mechanics; he guards its history. He has, in fact, composed a five-page account of its history (entitled, ordinarily enough, "Central Park Carousel History") that begins with its arrival in the park in 1871.

"In 1873," he writes, "the carousel opened." He then continues:

This carousel was powered by a blind horse and a mule. An attendant would stomp on the carousel platform, once to start and twice to stop the machine. Riders would enter from the southern end of the building and exit the northern end onto the 65th Street transverse road. At some point

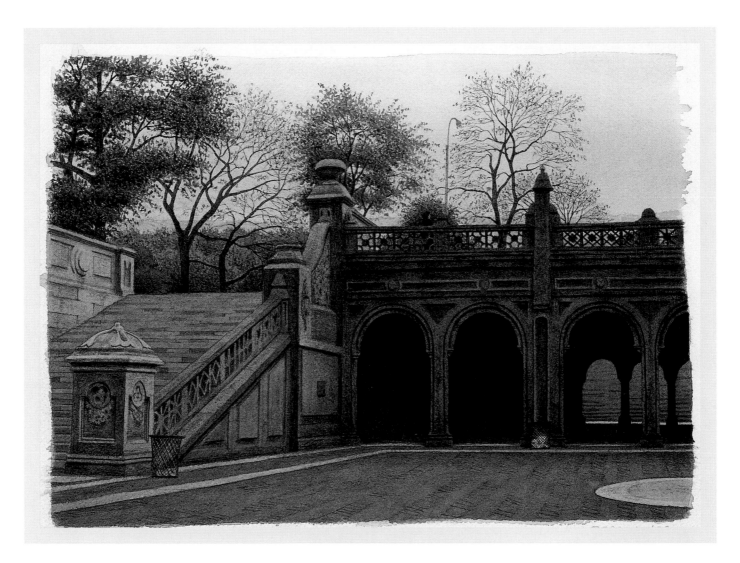

Bethesda Terrace.

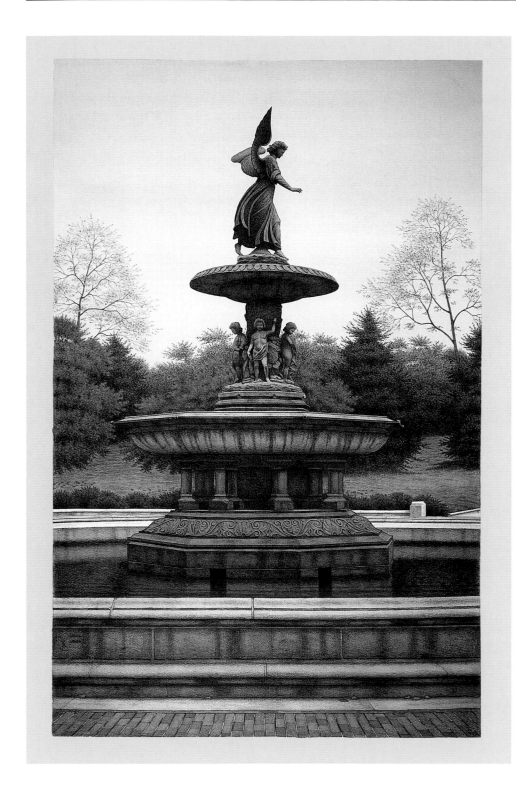

Angel of the Waters, Bethesda Fountain. The fountain is crowned with a graceful bronze angel, created by sculptor Emma Stebbins in 1873. She is based on the biblical story of the angel who came down to Bethesda Pool to stir the waters, after which the first invalid to step into the pool would be cured of affliction. Four cherubic figures beneath her represent purity, health, temperance, and peace.

in time, this machine was modernized either with a steam engine or an electric motor.

In the fall of 1950, the carousel burned down and was replaced by another found abandoned in a trolley terminal in Coney Island, a beach resort and amusement park in Brooklyn. To Mr. Napolitano, the old machine is akin to a cousin who died before his birth—unknown to him personally, but worthy of respect. The new machine, however, has for him an almost feminine allure. It is more like a mistress or a wife.

"If I hear a noise, even the slightest squeak, I know what's wrong with it," he said, cocking his head in demonstration of the skill. "I can hear a sound from a hundred feet away and know which horse it is."

When glitches occur, Mr. Napolitano will often stretch his legs and climb atop the cross-sweeps—the spokes that radiate from the carousel's pillar to the edge of the platform—and ride them like a gnat might ride an umbrella. His is a true family operation. The ticket booth is manned by his twenty-nine-year-old daughter, Nicole.

Despite such old-time ways, the small concessionaire has gone the way of the fedora and the phone booth, Mr. Napolitano explained, even in Central Park, home to the Bethesda Fountain and the Boathouse, where in the not-so-distant past, one could have encountered a shepherd on retainer in the Sheep's Meadow or a fellow with a team of Belgian drays drawing ice chariots across the park's frozen lake.

"Central Park is big business now," Mr. Napolitano said. "We're talking about millions of dollars for the city—millions. The little guy is gone. The

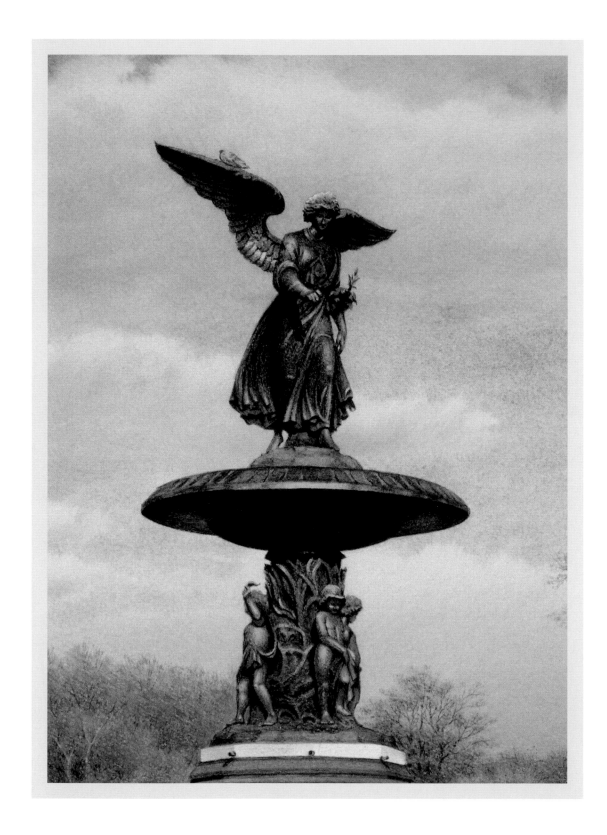

This late winter, early spring scene shows the pool drained of water, revealing a full view of the fountain, the statuary and pedestals stacked like a wedding cake and topped by the graceful Angel of the Waters. In the background, across the lake, the Loeb Boathouse sits surrounded by a landscape of dormant trees, some showing the first signs of the oncoming spring.

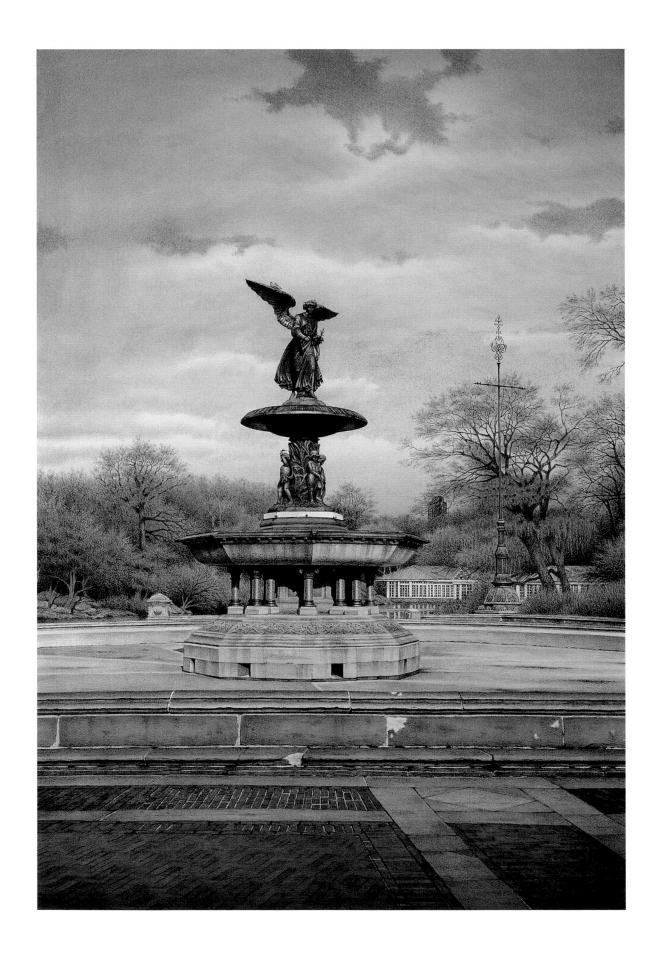

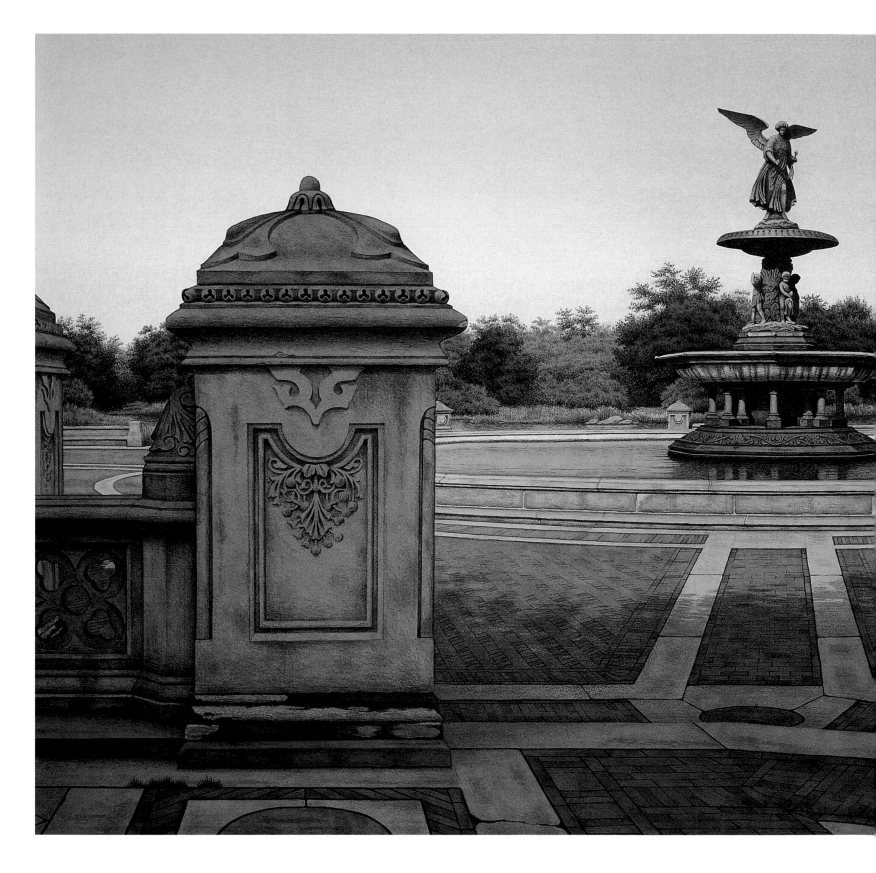

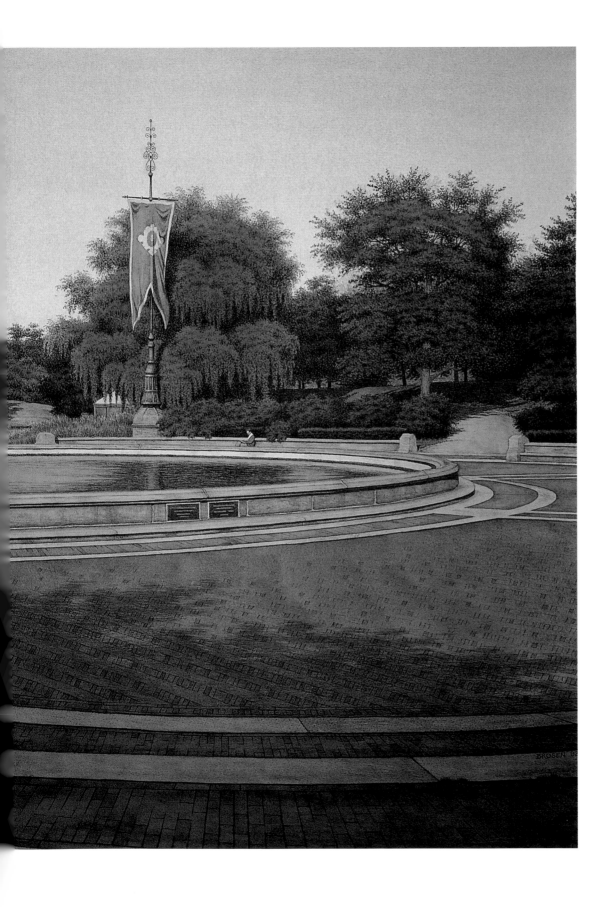

Bethesda Fountain Esplanade.
With the mall to the south and the lake to the north, the fountain and esplanade are the formal center of Central Park and create one of the most beautiful landscape designs in the world. The three-tiered fountain in the center stands twenty-six feet high and ninety-six feet in diameter. Frederick Law Olmsted and Calvert Vaux were committed to providing New Yorkers—young and old, rich and poor—with the most aesthetically uplifting experience possible.

mom-and-pops are gone." (He himself manages the carousel for a conglomerate named New York 1.)

Even family life, it seems, has proven vulnerable to the modernizing spirit. While the carousel has long been a place for birthday parties, at which children ride for hours, each taking turns on the lead horse, Bubbles, or his partner, Big Red, paid guardians have apparently taken over from parents, Mr. Napolitano said.

"At birthday parties these days, you're lucky to get two or three real mothers—it's mostly nursemaids and nannies," he said.

Of course, some things never change—Morris Bart, for instance. Mr. Bart visits the carousel every afternoon at one o'clock. He has done this for the last twenty years.

"I like to see the happy faces," Mr. Bart, an octogenarian, said. "I like to see happy people—it's refreshing. There's nothing ugly coming here."

This was a nice and very pleasant thing to say, and Sal Napolitano broke into a smile.

Loeb Boathouse.

In this view looking across Bethesda Fountain, you see the boathouse on the eastern edge of the lake where rowboats can be rented. The current boathouse was constructed in the 1950s and is also both a casual lunch stop and a more formal seafood restaurant, affording the diner an unsurpassed view of the lake and the fountain.

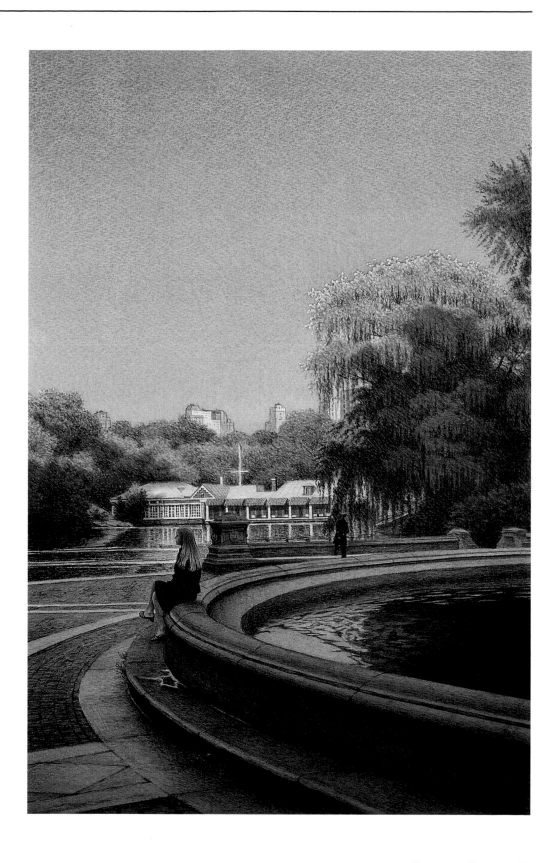

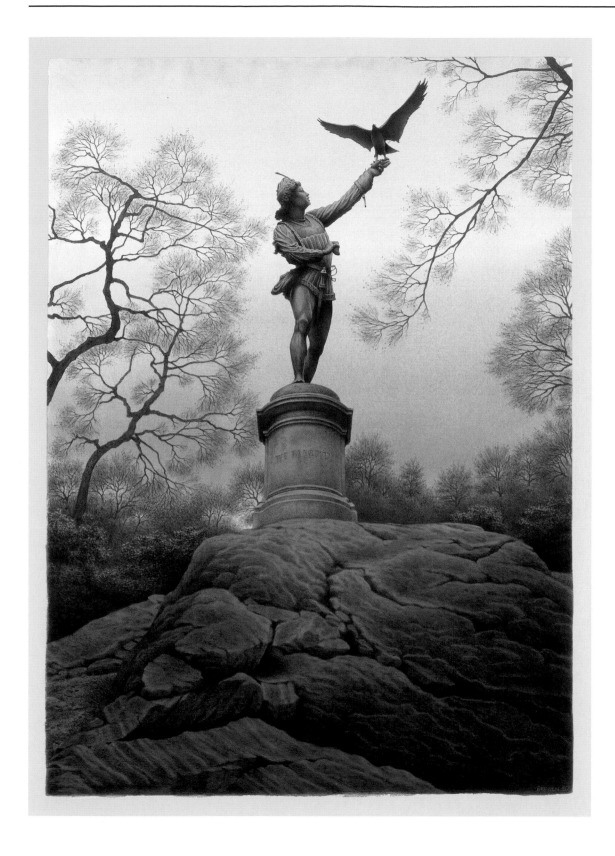

The Falconer.
*The Falconer by George Simmons
has stood high atop an outcropping
of rock along the 72nd Street Drive
since it was sculpted in 1872.
Summer foliage makes it easy to
overlook the bronze statue, but in the
winter, his elegant form stands
unobstructed and silhouetted against
the sky.*

OPPOSITE: *Burnett Memorial
Fountain, Conservatory Garden.
Bessie Potter Vonnoh sculpted this
intimate fountain in 1936. The
two bronze figures are based on
the main characters from Frances
Hodgson Burnett's classic children's
book,* The Secret Garden. *They
stand on a pedestal over a lily pond
circled with benches and cloistered by
overhanging trees. The Conservatory
Garden at 104th Street and Fifth
Avenue is the only formal garden in
Central Park, offering seasonal
blooms from early spring through
late fall. This peaceful oasis is a
favorite place of artists, children,
and local workers at lunchtime.*

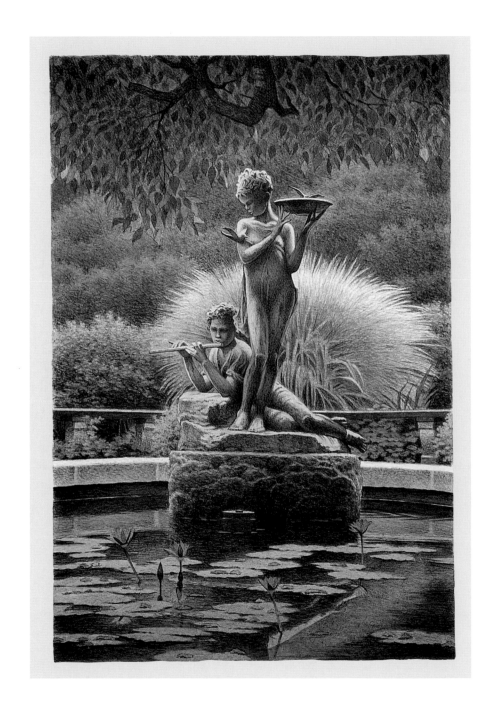

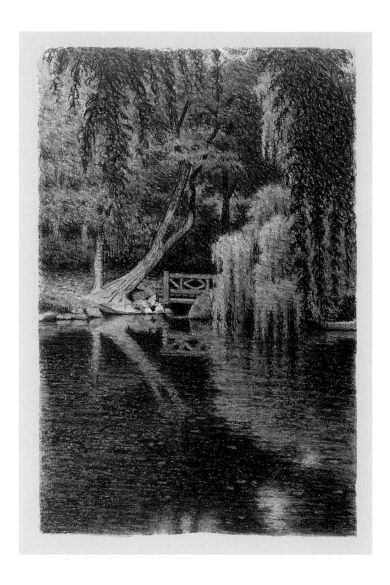

Central Park Studies.

ABOVE: *The Pool I.*
RIGHT: *The Pool II.*
OPPOSITE, TOP: *North Woods.*
OPPOSITE, BOTTOM: *North Meadow.*

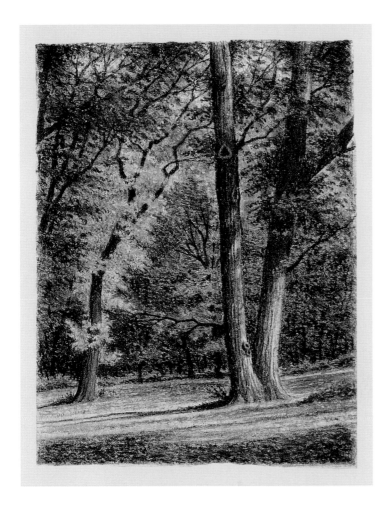

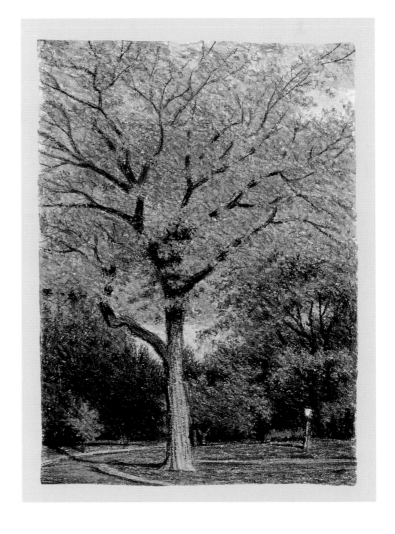

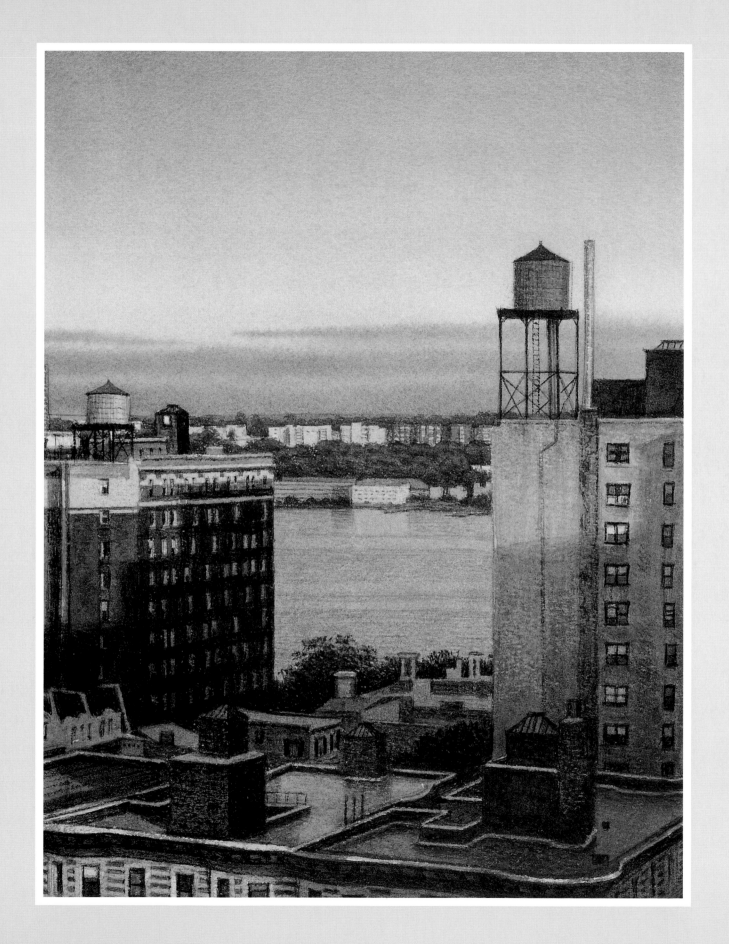

"IT'S US-VERSUS-THEM," LEONARD SOLOMON SAID WITH a shrug. His office phone had rung three times. The first was a call from a gentleman in search of an apartment—he was told there were none for rent. The second was a call from a workingman hired to fix the pipes—he was told he was late. The third was, by all evidence, a call from a leaseholder. "Don't slob up my place," he was told.

The "us" and "them" of Mr. Solomon's world are landlords and tenants, two species of the human genus as diametrically opposed to one another as the zebra to the lion or the debtor to the bank. Mr. Solomon has always been a landlord, and, while he understands the difficulties and the challenges of renting, he is a man of finite patience who believes there is nothing as important as the prompt delivery of a check.

"I'm as compassionate as the next one," he said the other day in his eyeglasses, wool suit, and necktie, "but, boy, if you treat me like a stink, you'll get stink back."

Detail of Upper West Side Rooftops.

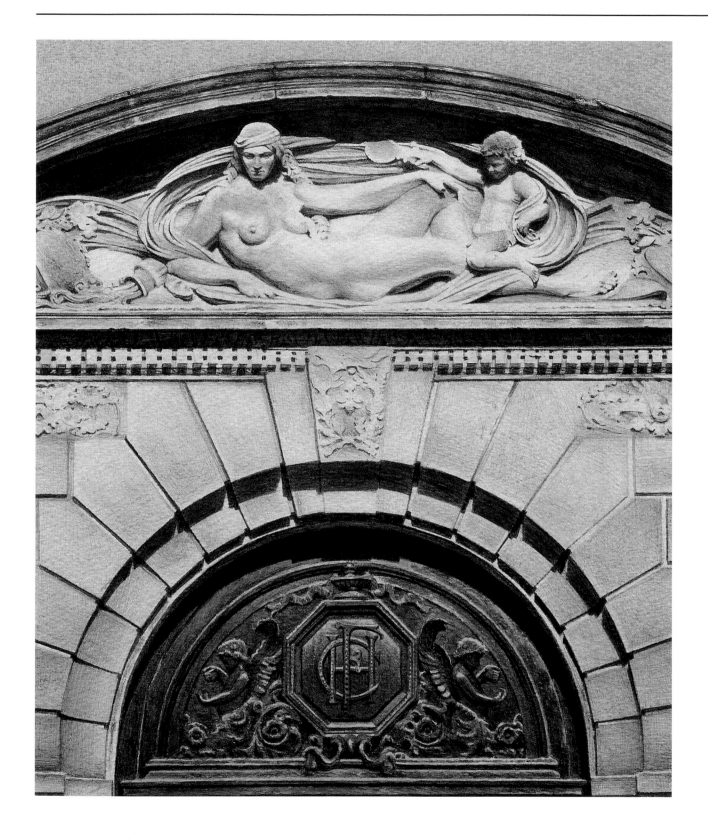

Mr. Solomon was sitting in his office at The Lancaster, a tidy brick six-story on the upper edge of West End Avenue, which he has managed on behalf of the man who holds the lease for several years. Mr. Solomon has spent the last five decades managing and owning uptown real estate, from Harlem to Manhattan Valley, the neighborhood that stretches from Columbia University down to Ninety-sixth Street. He grew up blocks from his office in a seven-room apartment with a maid's suite, which, in the early 1940s, let for the astronomical sum of $165 a month.

A landlord is perhaps the man most fit to unlock the history of any neighborhood, given that he literally own its keys. Mr. Solomon, for one, has seen quite a bit in his seventy-two-year residence uptown.

"When the Jews left Europe after World War II, they settled on River-side Drive in such numbers that it came to be known as the Hudson on the Rhine. Or the Rhine on the Hudson. Or the Rhone on the Hudson. Or some-thing the Hudson. Whatever. There were Jews. Then the Cubans came in, the good Cubans, in the fifties. Then the Dominicans—a different class of people. And now," he said, "the kids are coming back."

The Lancaster is a choice example of such socio-ethnic change. It was built a century ago as a luxury apartment house with a fancified name and four large suites on every floor. After the Depression, it became a rooming house for the working poor and was transformed again in the 1960s into studio apart-ments. Ever since, Mr. Solomon said, the hotel maids and civil servants who eke out lives in its rooms and hallways have been dying off or moving out—much, it must be said, to his delight.

"Turnover," he explained. "That's what helps."

Henry Clay Frick House. Above the main entrance to the Frick house, just off Fifth Avenue between 70th and 71st Streets are wood and stone carvings. The architects Carrere and Hastings used the motif, detailed here, to highlight the exquisite, yet restrained, Louis XVI style of the buildings. Constructed 1912–14, the house was intended from the outset to serve as a museum for Frick's remarkable art collection, and he resided here for only a few years.

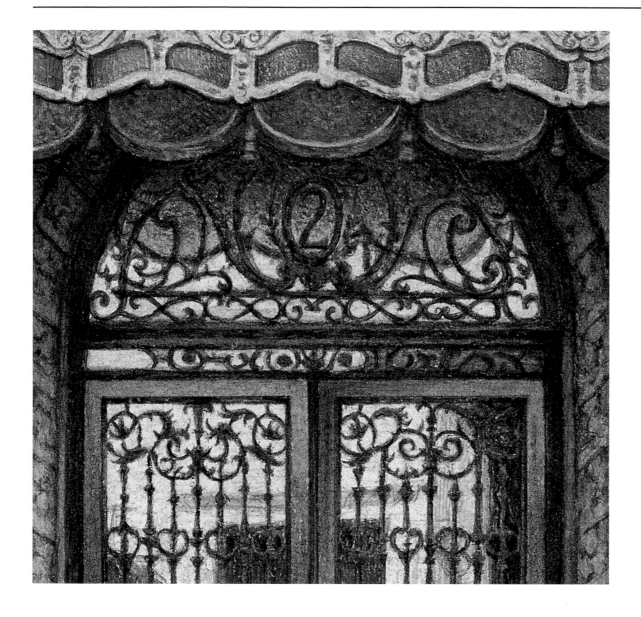

These days, there are seventeen apartments on every floor, 80 percent of which are occupied by college students. Mr. Solomon does not much care for the 20 percent who lack the courtesy to move or die. Like many landlords, he considers hangers-on as obstacles to raising rents. While his attitude could be taken as callous, it is not. It is business, Mr. Solomon says. The way he conceives of it, there are two kinds of undesirable tenants: Those who have no money and cannot pay the rent and those who pay the rent but stay.

Andrew Carnegie House.
Andrew Carnegie, once the world's richest man, erected his "Gilded Age" home at the corner of Fifth Avenue and 91st Street. Architects Babb, Cook, and Williard designed the mansion in 1898–1902 in Georgian style with French detailing, prominently featured in the copper and glass canopy above the main entrance. Today the house is home to the Smithsonian's Cooper-Hewitt, National Design Museum.

OPPOSITE: *Detail of the front door.*

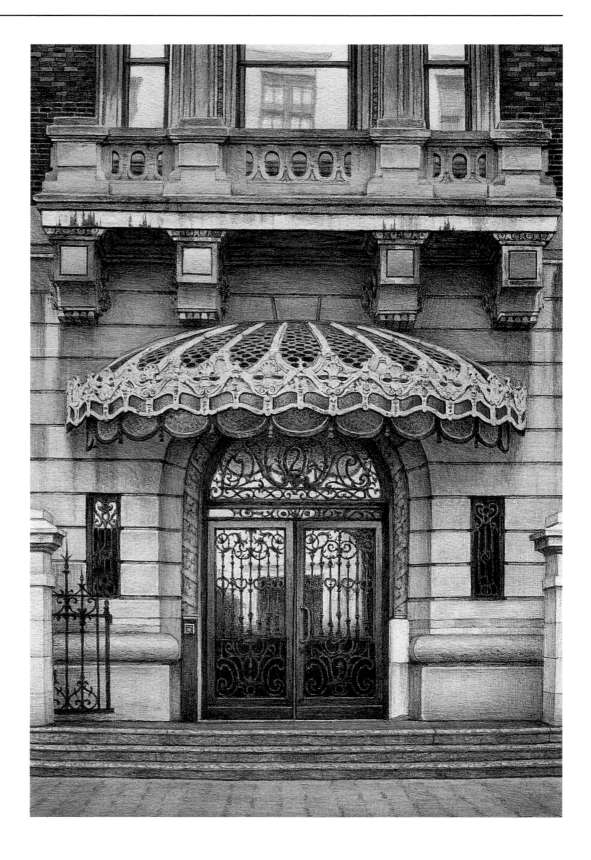

Among the tenants Mr. Solomon does not admire are dog owners, trumpet players, old Jewish ladies, and those who complain about the plumbing. His ideal renter is a young man in his early thirties with a well-paid job that requires him to travel out of town.

"If he's not around, he won't bang on the pipes if we cut the heat a little. But those old ladies who never leave the house are bang, bang, banging on the pipes all day. 'I'm cold! Give me heat!' They're the worst. Some of these

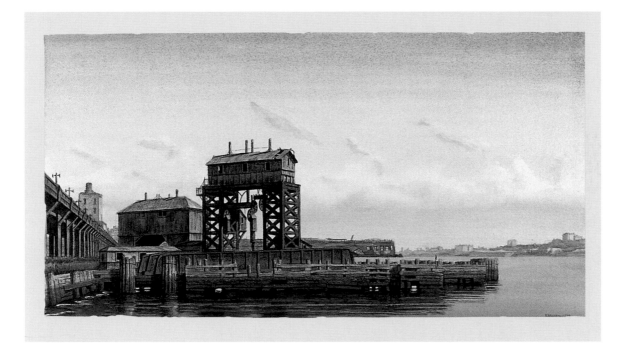

Riverside Park
along the Hudson River.
The docks and piers along the Hudson River, like buildings
on the city's streets, are in constant transformation.
Twenty years ago this was the view at 72nd Street, looking
towards the old loading docks that preceded the current
recreational pier.

OPPOSITE: *Broadway and 72nd Street.*
The broad expanse at Broadway and 72nd Street looking north
up Broadway serves as a classic gateway to the Upper West Side.
Several exceptional landmarks are here, including from left to
right, the Beaux-Arts Ansonia apartment hotel (1899–1904),
the IRT subway kiosk (1904), and the Central Savings Bank
(1926–28), modeled on the Pitti Palace in Florence.

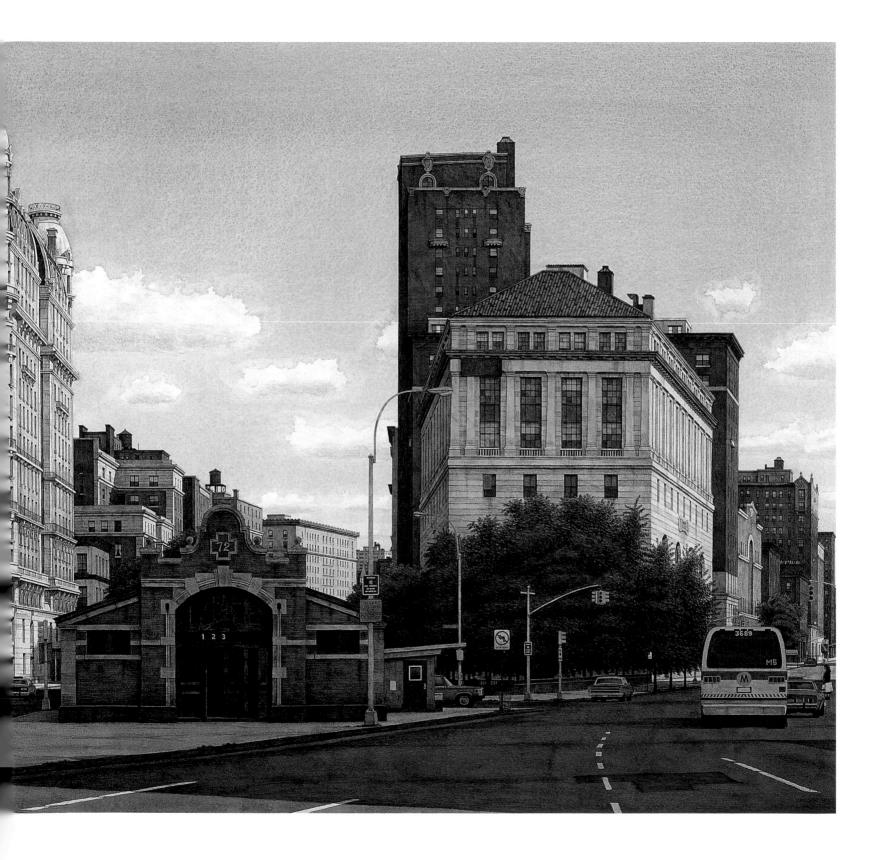

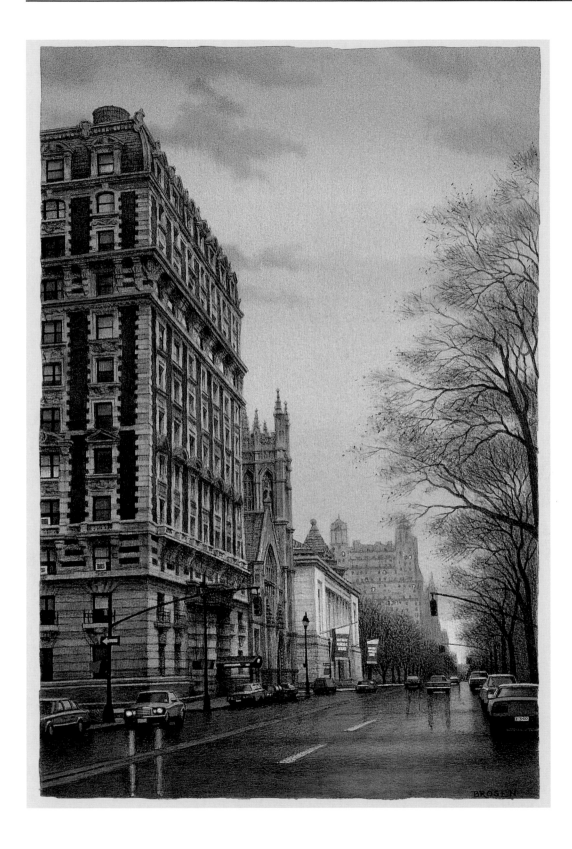

Central Park West.
Central Park West is one of New York's two gold coasts, each bordering the park. The east side along Fifth Avenue once boasted private mansions, while the west side was the preferred location for luxury apartments. This view looking north from 75th Street shows a range of turn-of-the-century buildings; the Kenilworth (1908), the Church of the Divine Paternity (now the Fourth Universalist Church) (1898), and the New York Historical Society (1903–08).

old ladies used to say, 'Oh, it's the landlord's birthday,' every time they paid the rent."

Mr. Solomon has never once in his career worked outside of uptown real estate. His grandfather, Pincus Cohen, was a landlord who employed him as a door-to-door rent collector for his own properties in Harlem, Manhattan Valley, and the Bronx.

On the third and thirteenth days of the month, a clean-cut Mr. Solomon, newly discharged from the army, would venture forth with little more than youthful optimism to collect checks from the blacks, Dominicans, and Jews who owed his family money. He is a real-estate traditionalist who, even now, maintains a management style that looks back to a vanished day. His tenants, for example, leave their checks with his superintendents in the old-time manner. He himself makes a daily round of his holdings, examining each one like a health inspector surveying a cut of meat.

"You don't find many left like me," he says. "Nobody goes to their buildings anymore. They're all big shots. They're all Donald Trumps. But if the tenants know I'm there, I don't have to pick up garbage. I don't have to check the basement. Even in my uptown buildings, people can't make a move without me knowing. I never miss a trick."

Of late Mr. Solomon has withdrawn from the market, keeping what he owns but avoiding new purchases because, he says, uptown is in a bubble.
"I wouldn't touch anything now. All of us who know what to do are sitting around with all this money. I'm not buying anything at all."

He is puzzled, for example, by the brick-and-glass monstrosity recently erected on Broadway and 107th Street, across from his office. He wonders if the

edifice will last. He wonders who will pay its million-dollar prices. He wonders
if the buyers are Chinese.

"Who's going to live there?" he asks aloud. "Who can afford such rent?
To me, it's all a bunch of poor slobs walking around these streets."
But as he shows a visitor the door, two young men are waiting in the hall. They
are students. They are looking for a room.

"You came for an apartment?" Mr. Solomon asks.

The young men nod.

"Do I know you?" he asks.

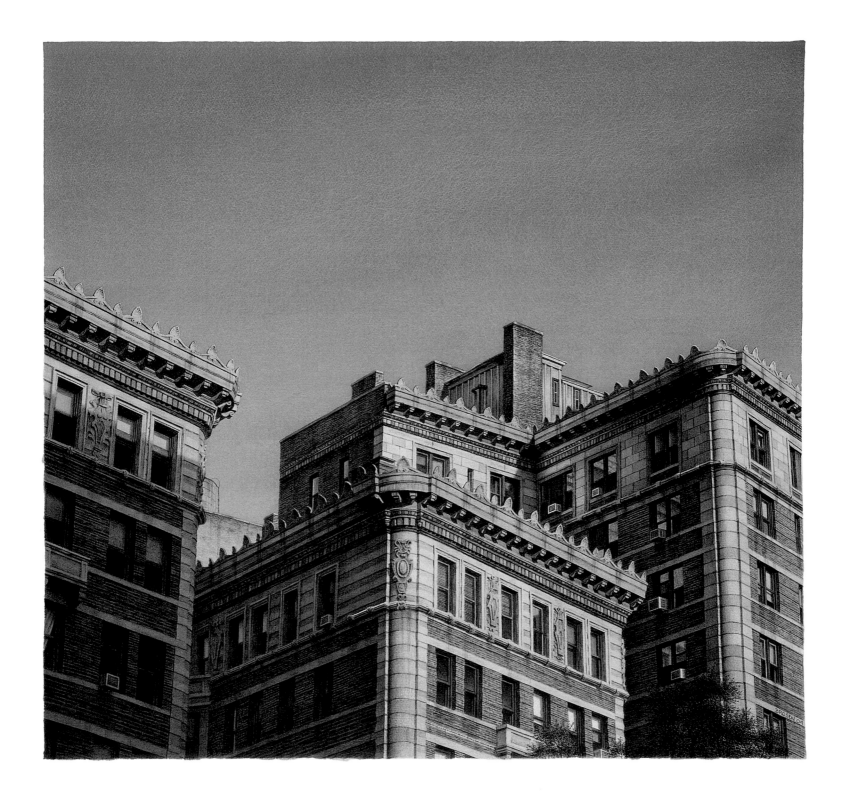

OPPOSITE: The Astor Apartments. The block-long complex on Broadway between 75th and 76th Streets was built in 1905 on land owned by William Waldorf Astor. Architects Clinton and Russell designed the buildings at an interesting angle to one another in order to follow the turn Broadway makes here as it heads north. Their position and their elaborate, oxidized copper cornices make them an especially striking feature of the streetscape.

225 West 80th Street.
The white facade and large projecting oxidized copper cornice at 225 West 80th Street stand strangely juxtaposed to an evocative ruin of urban history once again come into view. Vestiges of each floor can be discerned along the open brick wall that once supported a now vanished building. Since this painting was created in 2004, a tower has been erected between these two buildings.

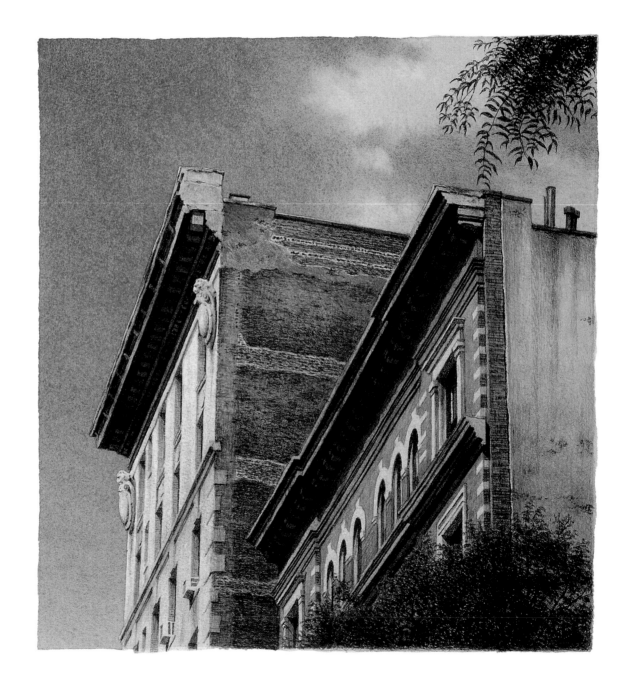

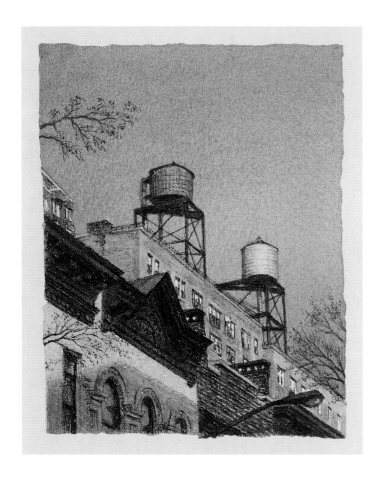

Uptown Studies.

ABOVE: *West 78th Street.*
RIGHT: *West 106th Street.*
OPPOSITE, TOP: *Broadway and 106th Street.*
OPPOSITE, BOTTOM: *Riverside Park.*

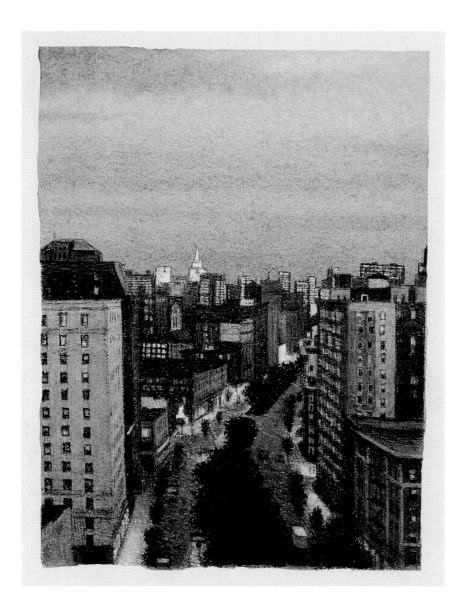

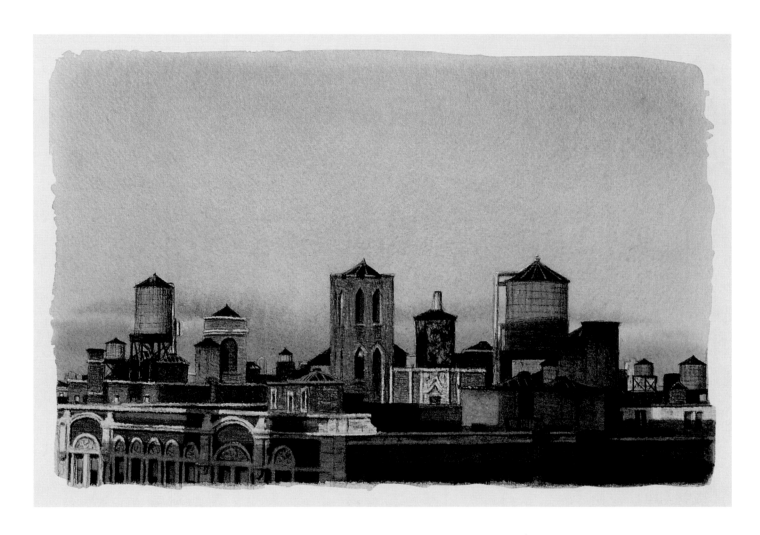

Above: Upper West Side Watertanks.
Opposite: Upper West Side Rooftops.

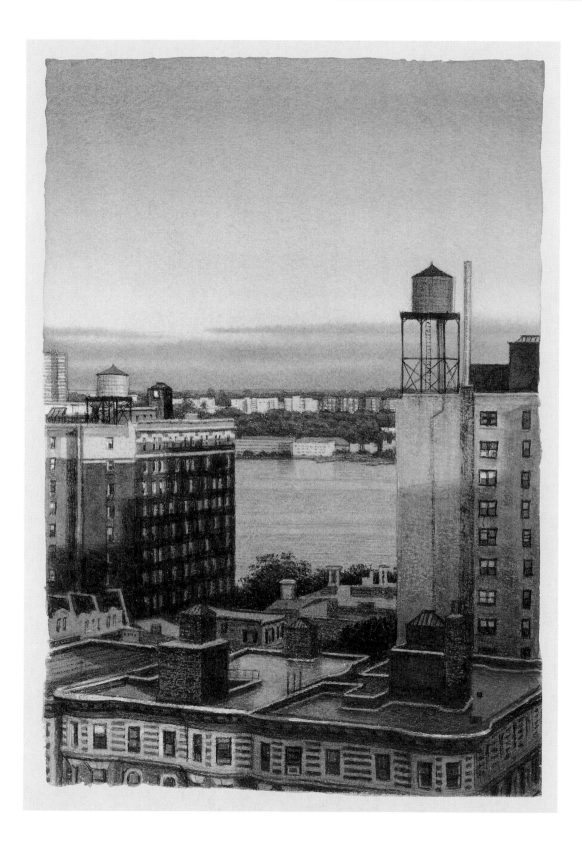

Hamilton Heights.
Originally developed in the early and mid-19th century, this area is named for
Alexander Hamilton, whose estate first occupied what is now 143rd Street. A second
round of apartment house construction was spurred by the completion of the City
College campus and the extension of the IRT subway line at the turn of the century.
These houses at 144th Street and Convent Avenue are part of a speculative development
of townhouses erected by William E. Mowbray between 1888 and 1890.

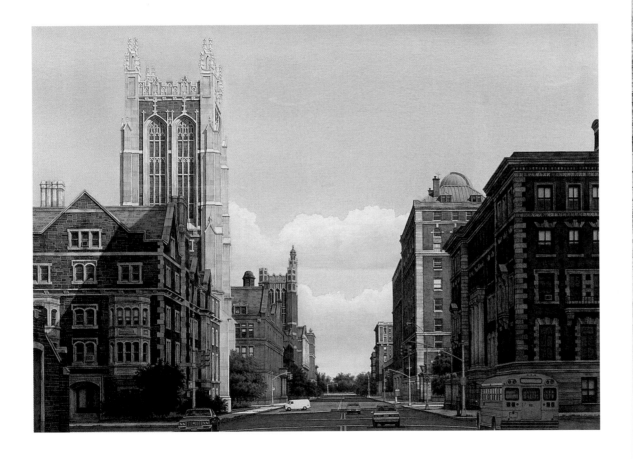

120th Street, view looking east from Riverside Drive.

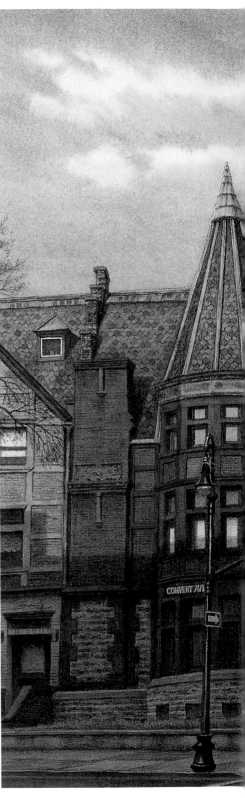

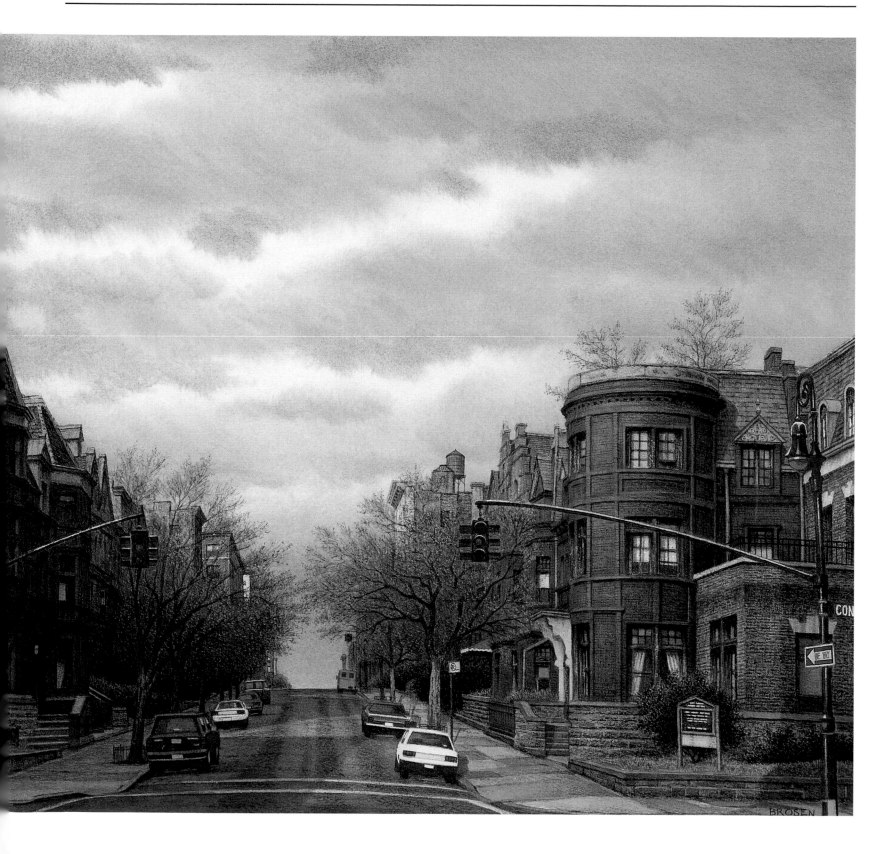

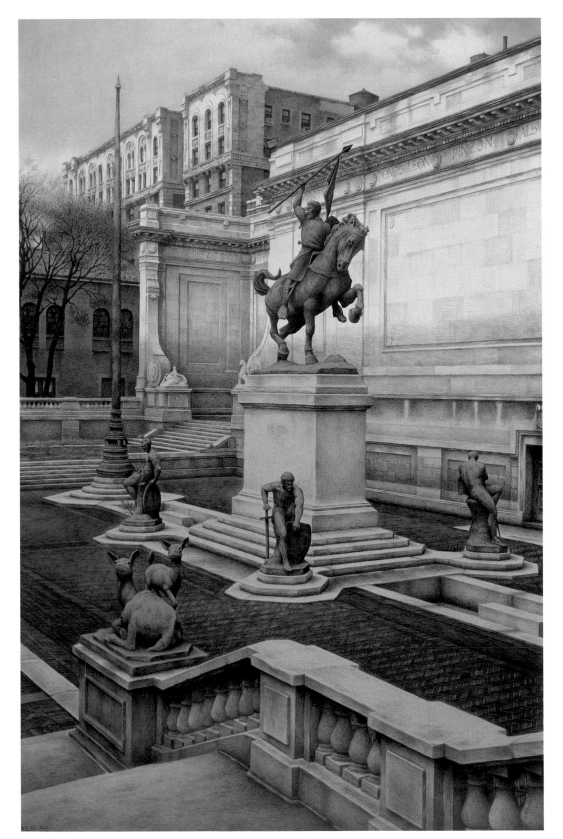

Audubon Terrace. Detail above.
Audubon Terrace, a turn-of–the-century Neo-Classical museum complex, is located between 155th and 156th Streets and was originally the site of John James Audubon's estate. Among the buildings is the Hispanic Society, which houses a remarkable collection of work by El Greco, Velasquez, and Sorolla. Its sculpture garden features this bronze equestrian statue of El Cid, legendary hero of medieval Spain. Anna Hyatt Huntington created the figure, surrounded by four seated warriors, in1927. The combination of bronze, limestone, and glazed red brick, makes this one of New York City's most striking public spaces.

*Lion House, Zoological Park,
the Bronx Zoo.
The exuberant Beaux-Arts Baroque
building is part of the original
1903 Bronx Zoo design by Heins
and La Farge, along with the still
standing Monkey House and the
domed Elephant House. The lion
house has now become administrative
offices, and the big cats roam more
suitably in extensive landscaped
enclosures.*

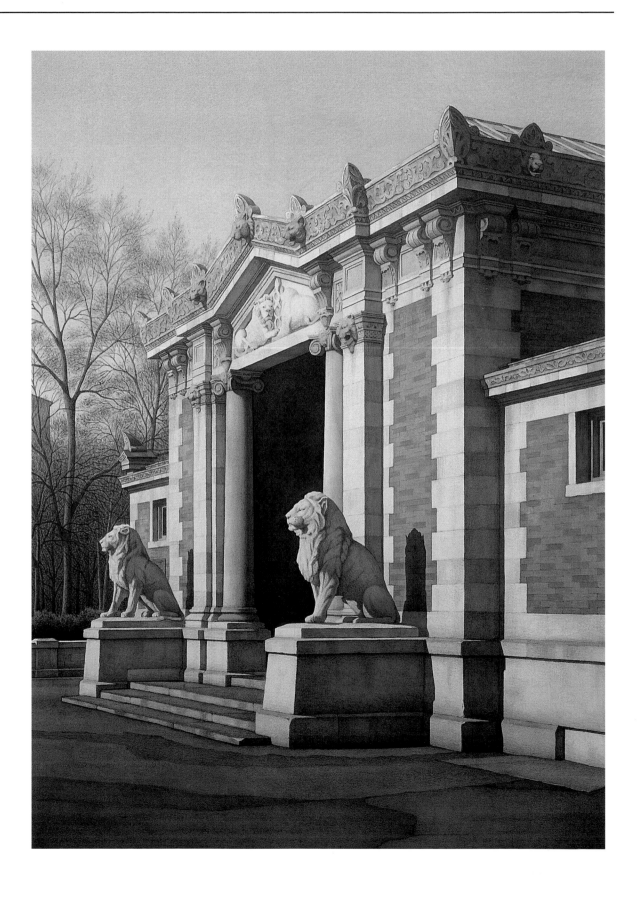

Engine Company 41, the Bronx.
This Neo-Renaissance turn-of-the century firehouse, located in the
Bronx at 150th Street between Courtland and Morris Avenues,
has been in continuous use by the New York City Fire Department
for one hundred years.

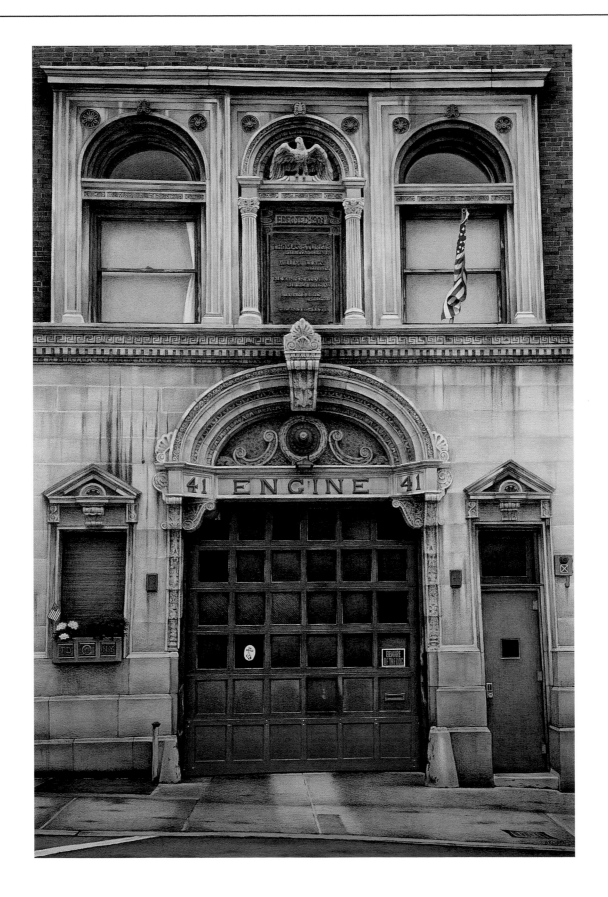

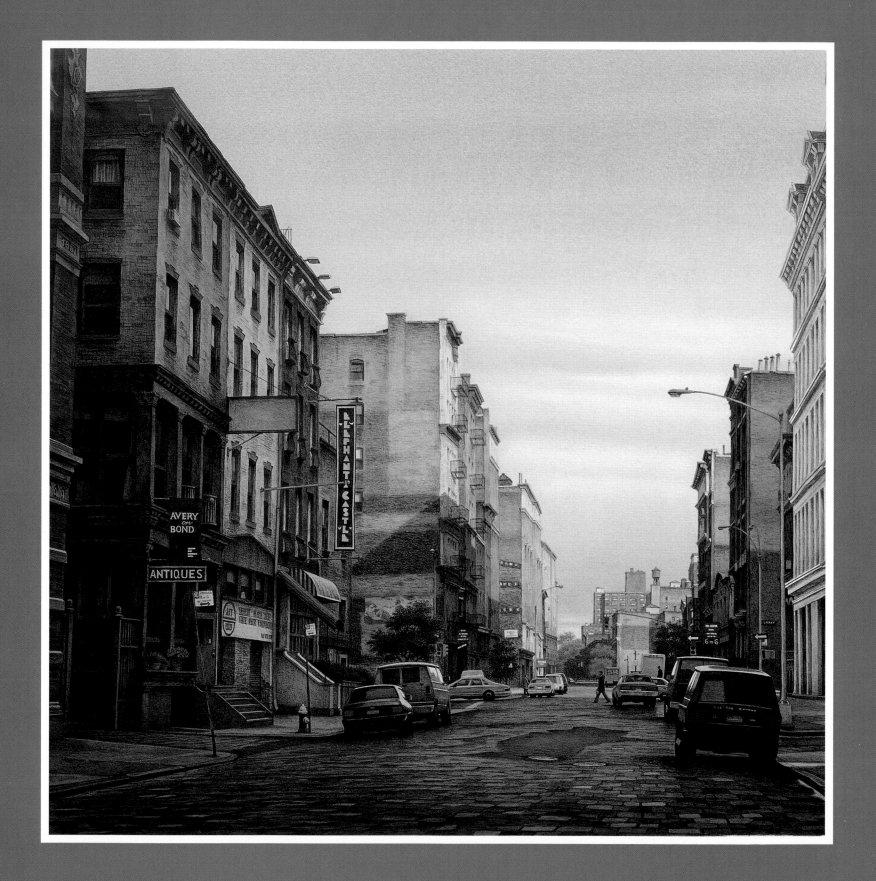

ACKNOWLEDGMENTS

I WOULD LIKE TO THANK THE FOLLOWING PEOPLE WHOSE FRIENDSHIP AND support have made this book possible: The dream team who worked directly on this publication and made the process such a pleasure: Mark Magowan, Sarah Davis, Ric Burns, Alan Feuer, Renée Khatami, and LTD Editions—Jane Lahr, Ann Tanenbaum, and Lyn DelliQuadri.

The directors of Forum Gallery, Robert and Cheryl Fishko in New York and Niccolo Brooker in Los Angeles.

Ann Bernhard and Bruno Quinson for their consistent belief in me and my work.

Pat and Jack Roche for their generous support over the past several years.

All my students who have taught me at least as much as I have taught them, and those who gave me the opportunity to teach at their institutions: Annette Blaugrund and Nancy Little at the National Academy of Design, Ira Goldberg at the Art Students League and David Gillison and Charles Seplowin at Lehman College, City University of New York.

Costa Vavagiakis, Sharon Sprung, Manuel Hughes, Shirley Loewe, Tom and Sally Birchard, Wei Qing Yuan, a great group of friends. Glen Castellano for the excellent photo work and Michiyo Fukushima for her invaluable assistance.

Alisa Hafkin for all the important years we shared.

Dr. William Lubart, a steady beacon during turbulent times.

My sister Lexi, brother-in-law Jon Birkhahn, and my niece Bryn, a vital and loving part of our small family circle.

My father, Alexander, from whom I inherited my love of New York.

Dorota Bobrowska, whose love, strength, and beauty are my inspiration.

To my son Sam and my daughter Isabelle, you are my greatest gifts. This book is my small gift to you with love.

Lastly, I want to express my deep appreciation for all my friends and patrons whose encouragement and guidance over the last several years have enabled me to live life in the only way I know, as an artist.

FREDERICK BROSEN

ALL OF THE PAINTINGS REPRODUCED FOR THIS BOOK ARE DONE ON 400-pound cold-pressed Arches watercolor paper, using a watercolor over graphite technique. Over a preliminary hard graphite under-drawing (using 5H or 6H leads), several layers of transparent washes are applied. Glazed layers of color are built up starting from the lightest, warmest tones and progressing to the darkest shadows. Details are added last, either with scumbling or dry brush and point-of-brush. Allowing the white of the paper to remain creates highlights. No gouache or opaque paint is used. Nine Windsor and Newton tube colors comprise the entire palette: cadmium red and yellow, cerulean and cobalt blue, raw and burnt sienna, rose madder, Payne's gray and Hooker's green.

For the large paintings, a final image is developed using on-site studies and drawings, and a combination of several photographs taken in varying weather and times of day. The finished composition is a composite of many views of the subject, sometimes quite literal, but more often simplifying and eliminating elements of the actual scene and subtly altering perspective and scale. Although intensely realistic, the result is not intended to be photographic, but a more subjective and interpretive sense of each specific place.

LIST OF PAINTINGS

LOWER WEST SIDE (*Tribeca, SoHo, Greenwich Village*)

Watts Street, 1998, 30 x 47 inches, Private Collection, endpapers, 30–31, 33.

Joan of Arc, 14th Street, 1992, 30 x 22 inches, Private Collection, 1, 41.

Gansevoort Street I, 1987, 28 x 47 inches, Private Collection, 19, 26, 36.

486 Greenwich Street, 1995, 31 x 25 inches, Private Collection, 19, 32.

Pier A, Battery Park, 1992, 27 x 42 inches, Private Collection, 29.

Broome Street, 1998, 36 x 27 inches, Private Collection, 34, 35.

Gansevoort Street II, 1997, 28 x 48 inches, Private Collection, 38, 38-39.

Washington and 14th Street, 1999, 22 x 32 inches, Courtesy of Forum Gallery, 40–41.

St. Veronica's, Christopher Street, 1987, 38 x 28 inches, Private Collection, 42.

Eighth Presbyterian Church, Christopher Street, 1988, 28 x 22 inches, Private Collection, 43.

LOWER EAST SIDE (*East Village, Little Italy, Chinatown*)

Brooklyn Bridge, 1992, 20 x 32 inches, Private Collection, 2–3, 46–7.

Woolworth Building, 2005, 18 x 12 inches, Private Collection, 7, 53.

Doyers Street, 2001, 42 x 30 inches, Private Collection, 23, 25, 50–51.

Broome Street and Bowery, 2000, 32 x 52 inches, Courtesy of Forum Gallery, 44, 58–59.

Canal and Centre Streets, 1986, 22 x 36 inches, Private Collection, 54.

54 Canal Street, 1994, 24 x 34 inches, Private Collection, 54.

Mosco and Mulberry Streets, 2003, 34 x 24 inches, Courtesy of Forum Gallery, 48, 49.

Canal and Division Streets, 2000, 44 x 32 inches, Private Collection, 55.

Engine 55, Broome Street, 1998, 42 x 30 inches, Frye Art Museum, Seattle, WA, 56, 57.

*Fourteenth Ward Industrial School,*1990, 16 x 14 inches, Private Collection, 60.

Mulberry and Prince Streets (Old St. Patrick's), 1997, 33 x 45 inches, Private Collection, 61.

Bond Street, 1997, 35 x 51 inches, Private Collection, 62.

Lafayette Street, 1992, 22 x 38 inches, Private Collection, 64.

Bleecker Street, 1986, 24 x 36 inches, Private Collection, 64.

Temperance Fountain, Tompkins Square Park, 1998, 42 x 30 inches, Private Collection, 65.

MIDTOWN (*14th to 59th Streets*)

Grand Central Terminal, 2004, 14 x 20 inches, Courtesy of Forum Gallery, 66, 84.

Library Lion, 2005, 16 x 12 inches, Private Collection, 69, 70.

MacIntyre Building, 1994, 30 x 20 inches, New York Historical Society, New York, 72.

Rutherford Place, 1994, 34 x 32 inches, Private Collection, 72, 73.

559 West 22nd Street, 1996, 30 x 20 inches, Private Collection, 74.

Fifth Avenue between 25th and 26th Streets, 2005, 9 x 6 inches, Private Collection, 75.

Sixth Avenue from 22nd Street, 2004, 14 x 20 inches, Courtesy of Forum Gallery, 76.

Broadway from 21st Street, 2004, 44 x 32 inches, Courtesy of Forum Gallery, 77.

MacIntyre Building, 2003, 4 x 3 inches, Private Collection, 78.

From Sixth Avenue, 2003, 4 x 2 inches, Private Collection, 78.

Rooftops West 20s, 2003, 4 x 3 inches, Private Collection, 79.

Broadway and 28th Street, 2003, 3 x 3 inches, Private Collection, 79.

Fuller (Flatiron) Building, 1994, 30 x 20 inches, Courtesy of Forum Gallery, 80–81.

25th Street, 1996, 32 x 46 inches, Metropolitan Museum of Art, New York, 82.

West 53rd Street, 2000, 18 x 22 inches, Private Collection, 85.

West and Fourteenth Streets, 1992, 20 x 48 inches, Museum of the City of New York, 136.

CENTRAL PARK

The Falconer, 1997, 35 x 25 inches, Private Collection, 86,.100.

Bethesda Fountain Terrace, 1996, 34 x 23 inches, Private Collection, 88, 89.

Bethesda Terrace, 1992, 8 x 12 inches, Private Collection, 91.

Angel of the Waters, 1993, 36 x 24 inches, Private Collection, 92.

Bethesda Fountain, 2003, 48 x 32 inches, Private Collection, 94.

Bethesda Fountain Esplanade, 1992, 22 x 44 inches, Private Collection, 96–97.

Loeb Boathouse, 2005, 16 x 12 inches, Private Collection, 99.

Burnett Memorial Fountain, 2005, 16 x 12 inches, Private Collection, 101.

The Pool I, 2001, 6 x 4 inches, Private Collection, 102.

The Pool II, 2001, 7 x 4 inches, Private Collection, 102.

North Woods, 2002, 6 x 14 inches, Private Collection, 103.

North Meadow, 2001, 4 x 2 inches, Private Collection, 103.

UPTOWN (*Upper West Side, Upper East Side, and Beyond*)

West 106th Street, 2000, 5 x 4 inches, Private collection, 5, 118.

Broadway and 72nd Street, 1992, 30 x 48 inches, Private Collection, 8, 11, 16, 111.

The Evelyn Apartments, West 78th Street, 1988, 14 x 22 inches, Private Collection, 12–13, 114.

Henry Clay Frick House, 2005, 11 x 12 inches, Courtesy of Forum Gallery, 106.

Andrew Carnegie House, 2005, 32 x 22 inches, Courtesy of Forum Gallery, 108, 109.

Riverside Park along the Hudson River, 1982, 12 x 22 inches, Private Collection, 110.

Central Park West, 1995, 18 x 12 inches, Private collection, 112.

American Museum of Natural History, 1989, 36 x 24 inches, Private Collection, 115.

Astor Apartments, Broadway between 75th and 76th Streets, 2004, 32 x 34 inches, Courtesy of Forum Gallery, 116.

225 West 80th Street, 2004, 18 x 14 inches, Courtesy of Forum Gallery, 117.

West 78th Street, 2001, 5 x 3 inches, Private Collection, 118.

Broadway and 106th Street, 2000, 8 x 5 inches, Private collection, 119.

Riverside Park, 2001, 6 x 4 inches, Private Collection, 119.

Upper West Side Water Tanks, 1998, 6 x 9 inches, Private Collection, 120.

120th Street from Riverside Drive, 1993, 30 x 42 inches Private Collection, 122.

Hamilton Heights, 1995, 18 x 28 inches, Private Collection, 122–123.

Audubon Terrace, 1998, 42 x 28 inches, New York Historical Society, New York, 124.

Lion House, Bronx Zoo, 1992, 38 x 30 inches, Private Collection, 125.

Engine Company 41, 2002, 44 x 30 inches, Courtesy of Forum Gallery, 126, 127.

NEW YORK CITY

Braley, Suzanne and Christopher Gray. *New York Streetscapes: Tales of Manhattan's Significant Buildings and Landmarks*, New York: Harry N. Abrams, 2003.

Burns, Ric, James Sanders, and Lisa Ades. *New York: An Illustrated History*, New York: Knopf; expanded edition, 2003.

Dolkart, Andrew S., and Matthew A. Postal. *New York City Landmarks Preservation Commission Guide to New York City Landmarks*, New York: John Wiley & Sons; second edition, 1998.

Fried, Frederick. *New York Civic Sculpture, a Pictorial Guide*, New York: Dover, 1976.

Greene, Liza M. *New York for New Yorkers: A Historical Treasury and Guide to the Buildings and Monuments of Manhattan*, New York: W. W. Norton; second edition, 2001.

McCaffrey, Brian R. *FHNY: A Pictorial History of Firehouse Architecture in the City of New York*, Woodlawn, 2002.

Miller, Sara Cedar. *Central Park, An American Masterpiece: A Comprehensive History of the Nation's First Urban Park*, New York: Harry N. Abrams, 2003.

Reynolds, Donald Martin. *The Architecture of New York City: Histories and Views of Important Structures, Sites, and Symbols*, New York: John Wiley & Sons; second edition, 1994.

Salwen. Peter. *Upper West Side Story*, New York: Abbeville Press; reprint, 1993.

Sims, Lowery Stokes, and Michael Henry Adams. *Harlem Lost and Found*, New York: Monacelli Press, 2002.

White, Norval, and Elliot Willensky. *AIA Guide to New York City*. Three Rivers Press, fourth edition, 2000.

FREDERICK BROSEN

Brosen, Frederick. *The Watercolors of Childe Hassam*, Watercolor Magazine, Spring 2005.

Hutton, Molly. *The Watercolors of Frederick Brosen*, The Gettysburg Review, Summer 2004, pp. 246–256.

Brosen Frederick. *Drawing as a Foundation for Watercolor Painting*, Drawing Magazine, Spring 2004, pp. 58–72.

Brosen Frederick. *The Ever Evocative Cityscape*, Watercolor Magazine, Summer 2000.

Karmel, Pepe. *Marginal Areas of New York City's Landscape*, The New York Times, August 11, 1995, Section C, p. 20.

Rivers, Valerie. *Precise Watercolors*, American Artist, July 1990, pp. 43–47, 73, 74.

John I. H. Baur. *Realism Today*, National Academy of Design Publication, 1987, pp. 56–57.

Russell, John. *Frederick Brosen: Recent Watercolors*, The New York Times, September 30, 1983, Section C, p. 20.

Wolf, Theodore. *The Home Forum: The Many Masks of Modern Art*, The Christian Science Monitor, July 6, 1982.

West and 14th Streets.
A view showing the old Cunard Line Terminal on the left
before its demolition to make way for the Chelsea Piers complex.